YOU *BACK THE ATTACK!*
WE'LL *BOMB WHO WE WANT!*

REMIXED WAR PROPAGANDA

Micah Ian Wright

Foreword by Kurt Vonnegut
Introduction by Howard Zinn
Commentary by the Center for Constitutional Rights

Seven Stories Press

NEW YORK | TORONTO | LONDON | MELBOURNE

In Canada: Hushion House, 36 Northline Road, Toronto, Ontario M4B 3E2

In the U.K.: Turnaround Publisher Services Ltd., Unit 3,
Olympia Trading Estate, Coburg Road, Wood Green, London N22 6TZ

In Australia: Palgrave Macmillan, 627 Chapel Street, South Yarra VIC 3141

ISBN 1-58322-584-6

College professors may order examination copies of Seven Stories Press titles free for a six-month trial period. To order, visit www.sevenstories.com/textbook, or fax on school letterhead to (212) 226-1411.

9 8 7 6 5 4 3 2 1

Printed in Canada.

"Naturally, the common people don't want war...but, after all, it is the leaders of the country who determine the policy and it is always a simple matter to drag the people along, whether it is a democracy or a fascist dictatorship or a Parliament or a Communist dictatorship.... Voice or no voice, the people can always be brought to the bidding of the leaders. That is easy. All you have to do is tell them they are being attacked and denounce the pacifists for lack of patriotism and exposing the country to danger. It works the same way in any country."

—HERMANN GOERING, AT HIS NUREMBERG TRIAL, 1946

"When the clock of civilization can be turned back by burning libraries; by exiling scientists, artists, musicians, writers, and teachers; by disbursing universities, and by censoring news and literature and art, an added burden is placed on those countries where the courts of free thought and free learning still burn bright. If the fires of freedom and civil liberties burn low in other lands they must be made brighter in our own."

—PRESIDENT FRANKLIN D. ROOSEVELT

"To announce that there must be no criticism of the President...or that we are to stand by the President right or wrong...is not only unpatriotic and servile, but is morally treasonable to the American public."

—PRESIDENT THEODORE ROOSEVELT

"They that can give up essential liberty to obtain a little temporary safety deserve neither liberty nor safety."

—BENJAMIN FRANKLIN

Contents

Foreword

BY KURT VONNEGUT

These antiwar posters by Micah Ian Wright are reminiscent in spirit of works by artists such as Käthe Kollwitz and George Grosz, during the 1920s, when it was becoming ever more evident that the infant German democracy was about to be murdered by psychopathic personalities, hereinafter "PPs," a medical term for smart, personable people who have no conscience. PPs are fully aware of how much suffering their actions will inflict on others, but they do not care. They cannot care.

The classic medical text about such attractive leaders into unspeakable calamities is *The Mask of Sanity*, by Dr. Hervey Cleckley. An American PP at the head of a corporation, for example, could enrich himself by ruining his employees and investors, and still feel as pure as the driven snow. A PP, should he somehow attain a post near the top of our federal government, might feel that taking the country into an endless war, with casualties in the millions, was simply something decisive to do today. And so to bed.

With a PP, decisiveness is all.

Or, to put it another way: We now have our own Reichstag fire to do something about. What will it be?

December 3, 2002
New York City

9

Acknowledgments

I would like to thank the Office of War Information and all of the brilliant artists who worked therein. The original versions of these posters were produced at a time when America was fighting a Fascist menace that threatened to cover the globe and strip us of our freedoms. Little could they have suspected that sixty years later, America would be the country the world fears and despises, and that our own government would be attempting to strip us of those same freedoms. It is in the memory of all artists who fought dictatorship, fascism, and tyranny that I dedicate this book.

Dissent and Democracy

BY HOWARD ZINN

I look at these "remixed" posters and feel a kind of chill. I remember them—at least some of them—in their original state (the photographs, not the words), when we were all involved in the "good war" and were being exhorted to "serve our country." We responded in various ways, I by enlisting in the Army Air Corps and then flying combat missions in the European theater (a strange way to describe it—a "theater") as a bombardier on a B-17.

The chill comes from the recognition that similar exhortations are going forth today to young Americans, inviting them to join the military, to participate in war. And the prospect of war, of young people going forth to kill, to die, has a sickening feel to it, far from the eagerness we had when we enlisted in the war against Fascism.

The difference comes from the experience we have had with war since that time long ago when the glow that surrounded "the good war" began to dim somewhat as we awoke to the horrors of Hiroshima and Nagasaki, Dresden and Tokyo. In what we thought would be a new world, as the United Nations proclaimed its goal "to end the scourge of war," there came instead a succession of wars—in Korea, Vietnam, Panama, Iraq, Yugoslavia, Afghanistan, to name just those in which the United States was involved.

Those wars do not give us a good feeling. They do not give us confidence in our political leaders. They do not assure us that our government has the interests of the American people as its first priority.

As I write, the United States is attacking Iraq with a massive air and land assault and, as with previous wars, justifying that with arguments that make no sense, that

promise certain immediate horrors with uncertain future consequences. All of this makes me welcome anyone who, like Micah Wright, a former U.S. Army Airborne Ranger, uses art to shock us into resistance to war. He does this by outrageously juxtaposing the images of "the good war" with the ugly realities of war in our time.

If these reworked posters were exaggerating what is going on today, that would be reasonable, given the historic role of art to extend our imaginations in such a way as to educate us, in the best meaning of "education," to make us more alive, informed, active citizens. But they strike me as not far removed from the daily headlines that tell us of more and more government attacks on the Bill of Rights, a growing atmosphere of intimidation, threatening the historic role of dissent in a democracy.

One of these posters, as redone by Micah Wright, declares: "Be a Good American. Don't Try to Think." His work in this book suggests to us defiance of that command.

Moment of Clarity

So I'm sitting amongst a crowd of 64 hot, sweaty, extremely aggressive men who are tweaking on adrenaline and gripping loaded automatic weapons with their itchy fingers. We're crammed inside of a vibrating metal tube 9 feet wide and 30 feet long and racing along at 300 miles per hour, 750 feet above the treetops of Panama.

See, I'm here on December 20, 1989, because—ha-ha, Merry Christmas, Micah—it's some brilliant politician's idea to invade the place, and since those politicians sure as hell aren't going to do it themselves, it falls to myself and my buddies around me: the cream of the U.S. Army's combat infantry, Charlie Company, Second Ranger Battalion/75th Ranger Regiment. We are the vanguard of Operation Just Cause, the "Liberation" of Panama. Unbeknownst to us, we're about to participate in the twelfth U.S. invasion of Panama since 1903.

Our mission is to jump out of a perfectly good airplane and attack the Panamanian Defense Force's Rio Hato Military Base, 65 miles west of Panama City. We've been told Rio Hato contains a large airfield and is home to two Panamanian Defense Force (PDF) companies: the Sixth Mechanized Rifle Company, equipped with 19 armored cars, and the Seventh Rifle Company, an elite counterinsurgency force known to be loyal to Noriega and trained by Uncle Sam at the School of the Americas (the college to which every self-respecting Third World dictator sends his troops in order for them to learn how to torture and kill their own citizens). Our mission is to destroy the PDF forces and seize the airfield for follow-on missions. The total number of PDF forces is estimated to exceed 500 men; these units, particularly the Seventh Rifle Company, are expected to offer stiff opposition to our 400 or so Rangers.

Anyway, I'm squatting in this shuddering tin can of a plane with 200 pounds of equipment strapped to my 180-pound body and I'm staring at the Red Light above the closed door and praying. "Sweet Jesus," I pray, "please open that goddamn door and let in some fresh air. I've been trapped inside this bottle with these 64 guys for six too-long hours and the smell of their fear, sweat, panicky acid stomach belching, and constant farting is about to make me throw up on myself and these guys will never allow me to forget that, so please, Jesus, open that damned door." Jesus is listening; the jump master opens the two side doors to the plane and Panama's hot, humid night air whips through the cargo bay. We're given the five-minute warning. We all attempt to stand, but our knees are lifeless after six hours in the plane. We finally make it to our feet and clip our parachute static lines onto the anchor cable.

Everyone's reciting things to themselves: Hail Marys, the Ranger creed, a guy in front of me is muttering the Boy Scout oath for some reason. The words to Johnny Cash's "Ring of Fire" are running through my head when suddenly above the steady vibrating thrum of the C-130 cargo plane's four giant Rolls-Royce turboprop engines, a sound rings out, reminiscent of my childhood in Texas: summer rain smacking into a corrugated tin roof. I look around, puzzled, trying to figure out what the new sound is, when suddenly the floor under my foot jumps. The jump master leans out the door, observing the upcoming drop zone. He pulls himself back in with a terrified look on his face and shouts, "The jump zone is hot!" and I realize that the Panamanians are shooting at our plane.

The pilots play it professionally: the plane doesn't shift from its course. We'd all heard horror stories from the older guys about the Grenada jump; some pilots freaked when they took fire and banked away from the drop zone, dumping several paratroops over a rock shoal in the middle of shark-filled waters, killing most of them. I feel comforted that my pilots aren't being so nervous. I think I'd have been less confident had I known that two planes in front of me a Ranger had just been shot dead while preparing to jump.

The light turns green. The jump chalk surges forward. Sixty-four men stream toward two three-foot-wide doors, all of us burdened with two parachutes, weapons, and a rucksack the size of a large child. One by one everyone leaps from the door-way. My turn. I experience a moment of panic as the image of my static line not dis-engaging from my parachute runs through my head—no one wants to become a

towed jumper, repeatedly smacking into the plane's fuselage at 350 miles per hour until you're a puddle of goo. Before I have time to freeze, though, someone shoves me from behind and I plunge out into the blackness below.

See, it's black because we're jumping at freaking 0100 in the A.M. only 500 feet from the ground. At 300 miles per hour. You try it sometime. Oh, and for full effect, have a bunch of people fire live ammunition at you as you hurtle toward the earth with only some blossoming pantyhose fluttering above you to keep you from taking a high-speed dirt nap six feet underground. It doesn't take but 40 seconds to get from 500 feet down to zero, but those are very long seconds when red tracers are whipping past your head, buzzing like angry bees. Nothing to do but hold on and hope you don't get shot. I drop my rucksack on its cord; I don't want to land with that heavy monster between my legs—I've seen guys break their hips and legs that way. I hit the ground still hauling ass and miss the paved runway by two feet; again, I'm lucky—I saw a lot of guys that night who shattered bones, knees, and elbows on that tarmac.

Once on the ground, I huddle behind my rucksack, looking for anyone around me to form up with. There's no one. Random rifle fire chews the grass to my right. I chamber a round into my rifle and huddle a little lower, looking for a target. Suddenly I remember what's in my rucksack: a claymore mine, ten grenades, and several hundred rounds of ammunition. Why the hell am I hiding behind this thing? I slip the heavy monster over my shoulders and move out. Eventually I meet up with some other strays and we form an impromptu fire team, moving out in a wedge formation, and fight our way to our objective points. Armored personnel parriers are rolling around all over the place. Rangers are lighting them up with LAW rockets and antitank rockets as fast as we can fire them. The noise and smell are awful as explosive after explosive smacks into those rolling deathtraps. "No Christmas for these guys," I think to myself as I watch an APC burn. We continue on toward our objective. Now the combat weight is really beginning to get to us; we're hauling 100 pounds apiece and it's 90 degrees with around 90 percent humidity. It's definitely not a dry heat and it's kicking our ass. In addition, our initial adrenaline rush has tapered off and we're crashing in a major way.

Finally we hook up with elements of Charlie Company and move out. Our job is to assault Manuel Noriega's beach house (not to be confused with the equally drug-infested MTV beach house) and hopefully capture the pineapple-faced dictator. We do one hell of a job. No one will ever again use that beach house once we finish with

17

it. Unfortunately, by this point, Noriega is already holed up in the Vatican embassy and out of our reach.

Eventually the moon sets and the sky is pitch-black. Unwilling to move around for fear of being shot by friendly fire, we set up defensive positions and gather wounded into the beach house. Come daylight, our mission at Rio Hato is complete.

The Rangers kicked ass; we did what we were trained for and we did it well. We jumped into direct fire and survived. We were proud of ourselves and of our unit. Midday, we rode helicopters into Howard Air Force Base and performed an after-action review. The next day we spread throughout Panama City to pull guard duty and to watch for Noriega's elite private guard, the Dignity Battalions. My unit was assigned to guard a section of the city near the PDF's military headquarters, the Commandencia.

And then everything in my life changed. Forever.

You see, the Commandencia was situated in the middle of Panama City right next to El Chorrillo, a crowded neighborhood of two- and-three story old wooden buildings. El Chorrillo was home to more than 20,000 of Panama City's poorest residents. At some point during the initial airborne assault on Panama City, the U.S. Air Force bombed the Commandencia. Several of their bombs missed their targets, exploding in this crowded, unsafe slum, setting fire to nearby buildings. The fire raged for two days; when it finally burned itself out, no one knew how many dead innocents lay in the ruins. What was startlingly apparent were the thousands of newly homeless poor people wandering the ashes, desperately looking for some shred of their previous lives or burnt loved ones. I never shot anyone who didn't shoot at me first—I didn't bury anyone in mass graves or burn their houses down—and yet, I share the guilt of those who did these things, because I was there. And guess what? So do you. Because it was your government that did it.

Standing in Panama City in 1989 on the roof of a six-story apartment building and looking out over a burnt-out ruin the size of a medium-sized American town, I had what alcoholics refer to as a moment of clarity: everything I had been told while growing up was a pack of lies. My pride in my unit, my cheery bravado, my "America first, last, and only" attitude died on that day. They had taken 19 years to develop through a carefully reinforced program of meme inculcation, but they were utterly swept away by what I saw.

I was a Navy brat; my dad was a nuclear engineer for the U.S. Navy, a stalwart

Republican. I had been a Cub Scout. I had learned to fire a rifle almost as soon as I could walk and spent happy summers shooting prairie dogs on my grandfather's cotton farm with a .30-06. My family moved a lot because of my father's military career; I went to three different schools to complete the fifth grade. I never had a friend for more than two years in a row. I was highly intelligent but emotionally isolated, perfect, I found out later, for the Special Forces.

So how does an upper-middle-class white kid from the suburbs wind up invading a foreign country? Well, one day I came home from high school and asked my father about college choices. He looked at me with an arched eyebrow and said, "You do know that I'm not paying for you to go to school, right?" It had never really come up before. Panicked, I began to look into student aid; unfortunately, my father made too much money for me to qualify for it. Ditto with student loans. Predictably, my dad suggested the Navy as a way to earn enough money for college. I took the ASVAB, the standardized test for military admissions. I scored a perfect score. Recruiters from every branch of the service began calling my house. Out of fealty to my dad, I went down and spoke to the Navy recruiter. I wasn't too impressed with their options. On my way out the Navy's door, I bumped into the Army recruiter, a Ranger. For a teenager in dire need of a lot of money for college and desperately searching for an answer, it seemed like he had a good one.

"The Rangers is a lot like being in the Boy Scouts," my recruiter told me. Hey, I'd been a Boy Scout. This Rangers thing sounded easy! Was it easy? "It is if you're committed," he said. "You even earn extra money every month for hazard pay," he told me, sealing the deal. An extra $150 per month sounds like a lot to a teenager.

Of course, he didn't tell me that one-third of all Ranger candidates drop on request due to the intense mental trauma, that one-third of them are failed due to life-threatening injuries obtained during Ranger training, or that Rangers are the first to fight in any war. Got to love that small print.

So, I suppose I "volunteered" for the Rangers. I'm constantly hearing from American news pundits that America's military is an "all-volunteer" force—as if that should preclude any guilt we may have when we send them to their deaths in service of an oil company's profits. Well, the best way I've ever heard it stated is that it's "voluntary" in the sense of "I can take this IBM job or go to Officer's Candidate School," and it's "voluntary" in the sense of "if the Army doesn't take me, I'm going to be on welfare." I was a case of the former. I met a lot of cases of the latter when I was in the

service. For the most part, the military is made up of solid people whose only chance of escaping terrible rural or urban poverty is to join up. My experience in the Army was that this country is horribly split amongst the protected and the protectors. African-Americans make up 12 percent of the U.S. population, but they make up 26 percent of the Army. The numbers are similarly skewed for Hispanics and Native Americans. Even worse are today's class divisions. Charlie Moskos, a military sociologist at Northwestern University, notes that during his senior year at Princeton University in 1956, 400 of 750 men who graduated went on to serve in the armed forces. Last year, in a class of 1,000 men and women, Moskos says, three Princeton graduates became military officers. It is impossible to discuss the fabric of America's military without noticing the absence of wealthy and upper-middle-class families. America is a country where a white, wealthy elite are protected by a poor, disproportionately minority underclass. "Be All You Can Be," indeed. Until we band together, the rich will always be able to hire half of the poor to kill the other half.

The best part is, their media will then cover it all up.

When I returned from Panama after New Year's 1990, my grandparents had not even heard that we'd invaded another sovereign country. A friend had recorded everything he could about the invasion, and when I watched the U.S. television news coverage, it seemed like I was watching a U.S. Army recruitment film: helicopters buzzing the foreign capital, "invisible" planes dive-bombing, American troops trotting down foreign streets, the enemy's headquarters engulfed in flames, friendly Panamanians welcoming the invaders as liberators. No television reporter mentioned that the Panamanians interviewed were almost always well dressed, light skinned, and English speaking, in a country where most were poor, dark skinned, and Spanish speaking. Television correspondents enthusiastically or matter-of-factly reported the bombings of El Chorrillo and other working-class neighborhoods, treating these aerial attacks on civilian populations as surgical strikes designed to break resistance in "Noriega strongholds." No footage was offered of El Chorrillo's total devastation.

As usual, the news media emphasized operational questions: Was the invasion going well? Was there much resistance? How many U.S. lives had been lost? How long would U.S. troops have to remain in Panama? Questions of international law and critical reactions from other nations were generally ignored. The UN General Assembly's overwhelming condemnation of the U.S. invasion was given scant notice in the mainstream media.

In covering the Panama invasion, many television journalists abandoned even the pretense of neutrality and independence. Some network correspondents could not bring themselves to call the invasion an invasion, referring to it instead as a "military action," "intervention," "operation," "expedition," "affair," and even the sexually charged "insertion." Network anchors used pronouns like "we" and "us" in describing the attack, as if they were members of the invading force or close advisors. NBC's Tom Brokaw exclaimed on December 20, 1989: "We haven't got [Noriega] yet." PBS announcer Judy Woodruff concluded on the following day: "Not only have we done away with the [Panamanian army], we've also done away with the police force."

Strange, I never saw Tom Brokaw humping an M-60 down the Rio Hato runway next to me. Perhaps I was distracted by the sight of Judy Woodruff providing covering fire on the runway control tower.

Operation Just (be)Cause turned out to be a dry-run rehearsal for Desert Shield/Desert Storm. The 1991 war on Iraq even featured a former U.S.-supported thug dictator as a convenient bad guy. Panama provided a solid proving ground for an entire generation of new Pentagon weaponry. Even better, though, the press-control techniques (reporter pooling, pre-airing footage censorship on "security" grounds, guided press tours of sanitized battle sites, etc.) developed in Panama were used to an even greater extent in the Gulf War.

As our country embarks on a new Gulf War, one in which we look to impose a Panama-esque "regime change" on Iraq, it might be informative to look at what has happened in Panama over the last 12 years since Dick Cheney's Operation Just (be)Cause: with the U.S. military firmly controlling Panama, conditions in that country deteriorated. Unemployment, already high because of the U.S. embargo against Noriega's regime, climbed to 35 percent as drastic layoffs were imposed on the public sector. Pension rights and other work benefits were lost. Newspapers and radio and television stations were closed by U.S. occupation authorities. Newspaper editors and reporters critical of the invasion were jailed or detained, as were all the leftist political party leaders. Union heads were arrested by the U.S. military, and some 150 local labor leaders were removed from their elected union positions. Public employees not supporting the invasion were purged. Crime rates climbed dramatically, along with poverty and destitution. Thousands remained homeless. Corruption was more widespread than ever. More money-laundering and drug-traf-

ficking occurred under the U.S.-sponsored Endara administration than under Noriega. By White House standards, the invasion was a success. It returned Panama to a Third World client state whose land, labor, resources, markets, and capital were again completely accessible to corporate investors on the best possible terms.

Anyone who believes that the outcome of an Iraqi, Iranian, or North Korean regime change will be any different is in desperate need of a moment of clarity. Hopefully theirs will not come while staring at piles of rubble and corpses.

To that end, I offer the following posters. I began making them after seeing some new posters that the National Security Administration issued a few months after the September 11, 2001, attacks. The NSA posters portrayed American servicemen and women in odd poses, such as an American sailor staring up and off to the right while smoke swirls around him from two vertical posts, evoking the 9/11 attacks.

As I looked at the poster, it suddenly struck me where I'd seen it before: it was a repainting of a Nazi recruitment propaganda poster urging young German men to join the SS. Rapidly deconstructing its meaning, I was sickened to realize that my government was deliberately using Nazi World War Two imagery to sell its new War on Terror (not to be confused with the War on Poverty, which we've evidently surrendered, or the War on Drugs, which have been supplanted by Terror as the raison d'être for stripping us of our rights). This use of fascist imagery to sell a new preemptive war struck me as Un-American to the core.

I immediately went to a few local poster shops and made color photocopies of some of their original World War Two posters. I bought a bunch of paint and started experimenting with removing the original text from those old posters, scanning the newly blank posters, and adding updated anti-fascist text. After posting a few to the internet and receiving wildly enthusiastic reviews, I spread my net a little wider, going to the local library and obtaining copies of other posters, shopping online for posters, going to the Smithsonian Museum's online offerings of posters, etcetera, and what I call the Propaganda Remix Project was born.

I'm up to 150 posters now, and as long as our government is seeking to shove fascist freedom-restricting laws down our throats and to roam the world starting preemptive wars to keep us "safe," I'll probably keep making more. You can find them all online at www.antiwarposters.com.

The posters I've worked on date from World War One to the 1950s, and come from Germany, the Soviet Union, Britain, Canada, and several other nations. All of

the posters appear in their original form in the book's appendix, along with the artists' names (when known), the country of origin, and date of publication. Most of the original posters are from the U.S. Department of War Information, the Roosevelt-era government propaganda production center.

Interestingly, the current administration is creating a new version of this department to propagandize the world about the inherent goodness of America while we simultaneously bully the United Nations and refuse to sign the International Landmine Treaty, the Kyoto Clean-Air Accords, the Chemical Weapons Ban, the Biological Weapons Ban, join the International Criminal Court, or to stop our "mini-Nuke" research which threatens to break the Nuclear Non-Proliferation Treaty and the Comprehensive Test Ban Treaty. This new version of the American propaganda machine certainly has their work cut out for them.

In closing, I invite you to begin reading the book and not to just dash through the posters. The accompanying text by the Center for Constitutional Rights is very illuminating and provides much more detail than I could ever fit on a poster. Only through education can we hope to change the minds of those around us who blindly obey every governmental edict to put plastic and duct tape over their windows and to vote the "correct" way.

Finally, I hereby order you to break the spine of this book and photocopy these posters onto larger-sized pieces of paper, and then glue them all over your school, neighborhood, protest placards, SUV car windows, or any other convenient place where they might be seen by one of America's unenlightened majority and hopefully change some minds before G. W. Bu$h covers the world with new piles of rubble and corpses.

<div align="right">

Micah Wright
March 2003

</div>

The bleak world portrayed in George Orwell's novel *1984* contains a Ministry of Truth that churns out lies, a Ministry of Peace that wages war, and a Ministry of Love that inflicts torture. The "Ministry of Homeland Security" does not appear on the pages of *1984*, but 21st-century America has a federal agency bearing the equally Orwellian title of the Department of Homeland Security.

On November 25, 2002, Bush signed the Homeland Security Act, which mandates the consolidation of 22 federal agencies with 170,000 government employees into a behemoth new agency. This law is causing the federal government to undergo its largest reorganization since the formation of the Department of Defense in 1947, and the process of pulling this agency together is certain to encounter a tangle of bureaucratic snafus, turf battles, and other distractions. As Senator Robert Byrd warned when he voted against the Homeland Security Act, "Osama bin Laden is still alive and plotting more attacks while we play bureaucratic shuffleboard."

So what do you think? Are we more secure with our new Department of Homeland Security?

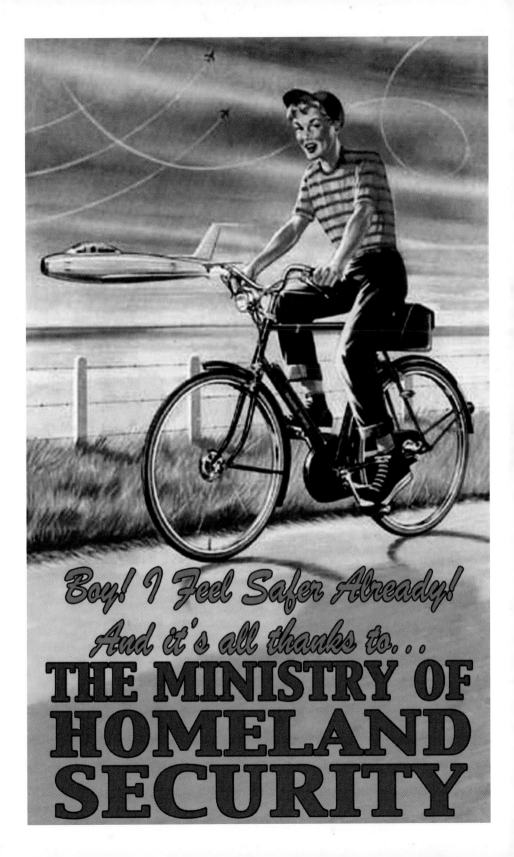

America's hunger for oil and other nonrenewable energy sources is voracious. With less than 5 percent of the world's population, the United States consumes more than 25 percent of the world's oil and is its largest producer of greenhouse gases. Despite growing scientific evidence that the burning of fossil fuels contributes to global warming, the Bush administration appears dead set against controls on oil consumption and pollution, both domestically and abroad. In March of 2001, the administration shocked the world by withdrawing from the Kyoto Protocol, an international agreement designed to reduce carbon dioxide emissions worldwide over the next ten years. Approximately 180 nations, including the European Union and Japan, have ratified the Protocol.[1]

The U.S. stands apart from an international community determined to take responsibility for preserving the planet. The reasons President Bush has offered in support of this decision are hopelessly shortsighted—that more populated countries whose per capita consumption of oil was considerably less than that of the U.S. are subject to less restrictive standards under the treaty, and that the treaty's restrictions could hurt the U.S. economy.[2]

So what lesson should those concerned about the future of the planet take from President Bush's decision to withdraw from the Kyoto Protocol? If you don't like what you're breathing, just wear a gas mask. And if you're too warm, just turn on the air conditioner!

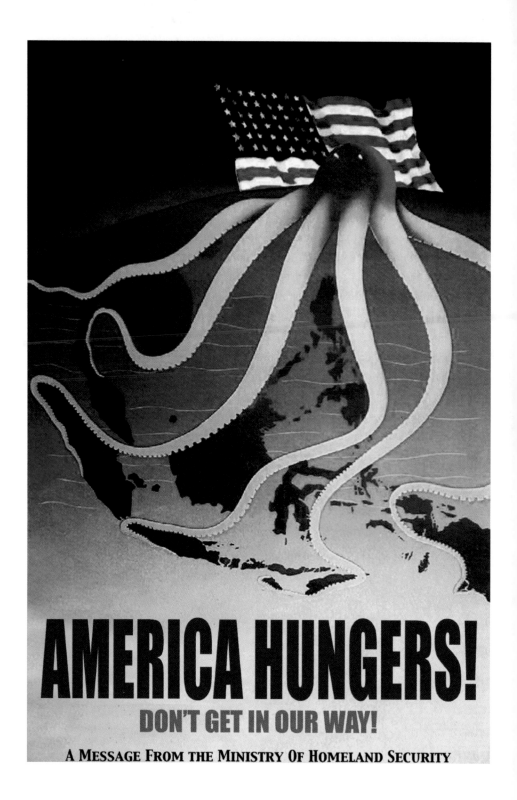

New studies show that gas-guzzling sport utility vehicles (SUVs) are great at killing people even when war for oil is not on the agenda. It has long been clear that SUVs pose a danger to other drivers: for large SUVs the "kill rate" upon hitting the side of another vehicle is almost five times higher than that for the average car.[3] What is less well known is that SUVs are also unsafe for occupants due to their nasty tendency to roll over.[4]

How do automobile companies get away with making such a dangerous product? They have a lot of protection. In what is known as a "legal fiction," corporations are treated as "persons." This serves to shield the people who actually make the decisions from most civil and criminal liability. "Incorporation" allows individuals to put money into a venture and act on behalf of that venture without risking more than their initial contribution. For example, should a jury ever decide that Ford acted "recklessly" by designing high-riding SUVs without safety beams to keep them from riding over smaller cars in head-on collisions, the only punishment in the prosecutor's arsenal would be a monetary fine. A corporation cannot be put in prison, and it is extremely difficult to hold corporate officers personally responsible. Even if a fine forced the corporation into bankruptcy, it would have no direct consequence on the personal fortunes of the individuals who made the business decision to market such a lethal device.

Through the U.S. Armed Forces Code of Conduct, a soldier affirms: "I am an American fighting in the forces which guard my country and our way of life. I am prepared to give my life in their defense."[5] The code does not extend to attacking other nations without provocation, meddling in the affairs of other countries to impose puppet regimes, or attempting to control the world's oil-producing regions.

The Bush administration would undoubtedly like to pass off its attack on Iraq as having a humanitarian mission. In an address to the graduating class at West Point on June 1, 2002, President Bush said of America's military, "We have a great opportunity to extend a just peace, by replacing poverty, repression, and resentment around the world with hope of a better day."[6] These high-flown words notwithstanding, this preemptive war on Iraq has lead to civilian deaths and threatens to devastate that nation's infrastructure. In calling upon our soldiers to fight this war, our commander-in-chief corrupts their honorable calling.

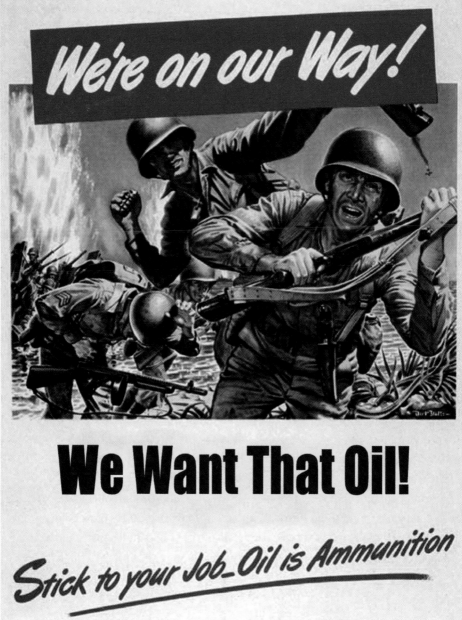

We're on our Way!

We Want That Oil!

Stick to your Job_Oil is Ammunition

A MESSAGE FROM THE MINISTRY OF HOMELAND SECURITY

The Bush administration has saturated the media with "war equals economic security" rhetoric. But the idea that war can salvage our struggling economy is contradicted by economic indicators. On January 21, 2003, an MSNBC headline read, "War Worries Whack Blue Chips, Dow Industrials Drop 144; Nasdaq Composite Slips 12." This is but one of many warnings of the economic dangers of an endless war in Iraq.[7]

In the summer of 2001, by all media accounts, the United States was rapidly running out of money. Some proposed the grim prospect of dipping into Social Security trust funds. With the events of September 11, 2001, we have seen diminished government revenues, calls for drastic tax cuts, and the prospect of a bottomless pit of expenses associated with what appears to be a perpetual "war on terrorism."

Expectations that economic reinvigoration, such as that fueled by World War II, will follow this invasion of Iraq are misguided. Much of the heavy industry that fueled the postwar boom has relocated overseas. And the International Monetary Fund has warned that ousting Saddam Hussein could harm our economy by engendering worldwide market panic. After all, economic growth took a deep and swift slide after the 1973 Arab-Israeli conflict, the 1979 Iranian revolution, and the 1991 Gulf War.

Destabilizing the world economy and plunging into oil wars might work well on a reprise of the TV show *Dallas*, but not in the real world. The dreadful economic consequences of war will fall on the civilian populace on both sides of the conflict. With the price of a barrel of oil skyrocketing from $18 in 2000 to over $32 in 2003, the coffers of oil companies are lined with profits squeezed out of consumers. The oil companies stand to be further enriched if Iraq's rich oil reserves come up for grabs. At the same time, the costs of war will be paid out of funds that could be used to address hunger, poverty, and disease, both at home and abroad.

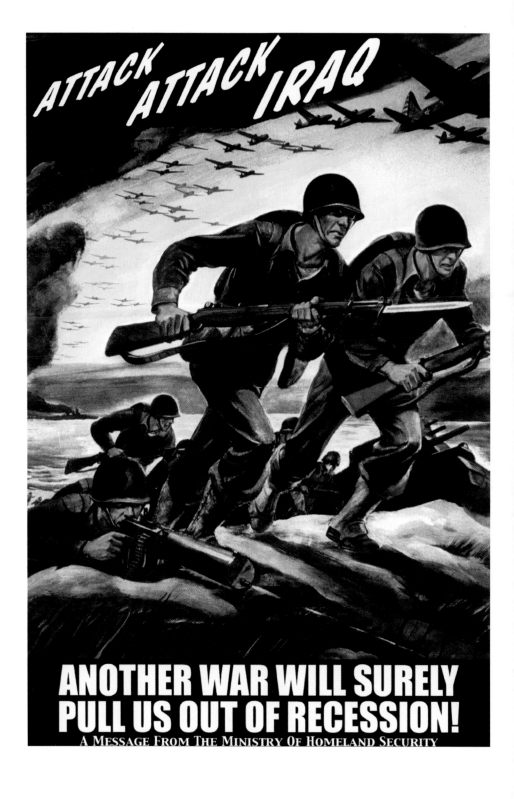

This young man has the U.S. Congress to thank for the "No Child Left Behind in Education Act," a law that took effect on January 8, 2002, and is opening up exciting new career opportunities for high school students all across the nation.[8] As its title suggests, the law's goal is laudable—to ensure that all children have "a fair, equal, and significant opportunity to obtain a high-quality education." But tucked away in this law is a provision that promotes the military recruitment of high school students. This provision requires high schools to provide military recruiters with the names, addresses, and phone numbers of enrolled students as a condition of receiving federal education funding.[9] This information is provided automatically, except when a student or his or her parent affirmatively submits a written request that the school not do so.[10]

Many legal provisions protect the safety and well-being of our young people. But, with assistance from Congress and our public school system, today's young people are allowed to sign away their freedom—and even their lives—to the military.

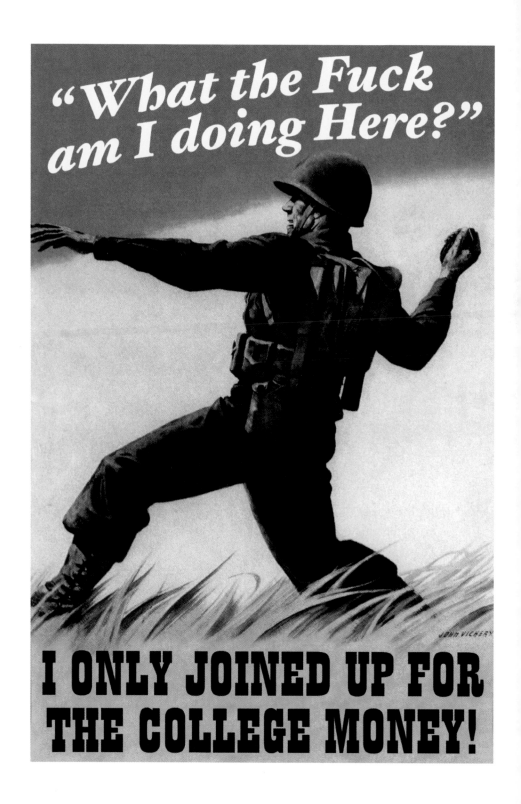

The United States has an ugly history of killing innocent civilians. During the Vietnam War, the U.S. military conducted indiscriminate bombing missions that led to an estimated two million civilian deaths. On a number of these missions, the U.S. military dropped napalm, a highly volatile "jellied" gasoline that burns its targets on contact; and Agent Orange, a toxic herbicide, killing and maiming the population and denuding the landscape.[11]

During the 1991 Iraq war, the U.S. was responsible for up to 15,000 civilian deaths, many of which resulted from the bombing of Iraqi electrical grids and hydro-electric dams.[12] And in December 1998, the United States once again bombed Baghdad, killing and maiming hundreds of Iraqi men, women, and children. Within the first six months of the ongoing Afghan war, from October 2001 to March 2002, U.S. troops killed approximately 3,000 civilians when it blanketed "dumb" bombs over heavily populated areas of Afghanistan.[13]

And now our government has preemptively attacked Iraq, an act of international aggression that is sure to bring about more terror—not only to the people of Iraq but also to those of us in the United States. The Pentagon's high-tech war on Iraq exercises a strategy of "rapid dominance," or "shock and awe," in the words of Chinese military philosopher Sun Tzu. Its goal is to promote fear and confusion by hitting Baghdad with a barrage of cruise missiles in the opening days of the war. Harlan Ullman, one of the authors of the plan, told CBS News, "You...take the city down.... You get rid of their power, water. In two, three, four, five days they are physically, emotionally, and psychologically exhausted."[14] An unnamed Pentagon official summed it up: "There will be no safe place in Baghdad." Before this plan was leaked to the public, a confidential United Nations report predicted that "as many as 500,000 civilians could require treatment...as a result of direct or indirect injuries" sustained during any future war with Iraq. Under "shock and awe," these figures will surely rise, as Baghdad is home to more than four million people.

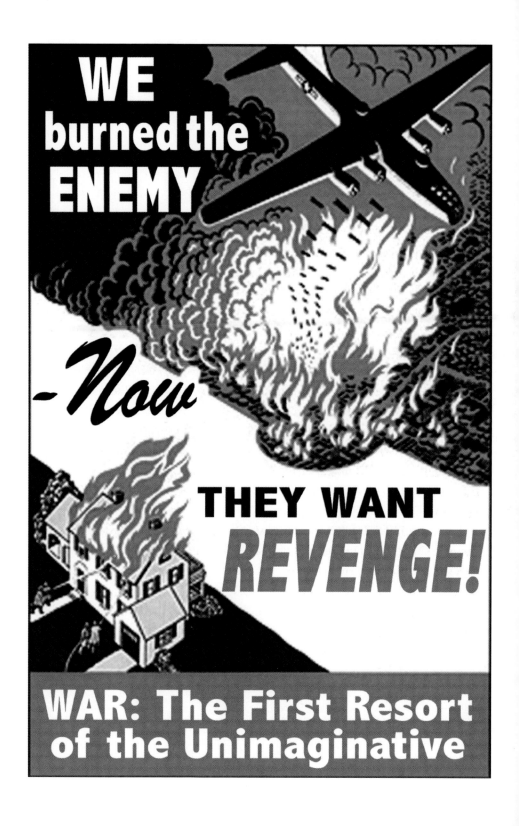

The World War II version of this poster exhorted Americans to make personal sacrifices to support the war effort. The poster and others like it were effective. Americans suffered through wartime supply shortages and the rationing of necessities without complaint, and they willingly contributed their time and possessions to the common cause.

Instead of asking Americans to tighten their belts, President Bush has promoted unrestrained consumerism as a solution to the nation's ills. His economic stimulus package after September 11 was designed to "boost consumer confidence" and "to make sure that the consumer has got money to spend, money to spend in the short-term."[15] In essence, President Bush has encouraged people to spend beyond their means, and he has followed his own advice. Under the Bush administration, the federal budget has shifted from a surplus at the beginning of his term to a deficit of $200 billion. It is predicted that the deficit could rise to a record $304 billion by the end of Bush's third year in office.[16]

Bush's plan? To abandon communal sacrifice for conformist consumerism. To preserve an extravagant lifestyle at all costs, and let the next president (along with all the rest of us) worry about paying for it later.

WE'LL TAKE CARE OF THE AXIS OF EVIL

YOU TAKE CARE OF DOMESTIC DISSENT!

V— 1. Vote as you're told.

I— 2. Gladly pay your War Tax raises.

C— 3. Don't ask questions. About anything.

T— 4. Watch your neighbors. Especially foreign ones.

O— 5. Forget what your 401(k) used to be worth.

R— 6. Don't worry about the environment.

Y— 7. Remember – Patriotism requires Blind Obedience.

A MESSAGE FROM THE MINISTRY OF HOMELAND SECURITY

Because the poor do their fighting for them. And don't expect Daddy's friends in the Bush administration to be donning uniforms either. Notwithstanding President Bush's perplexing assertion, "I've been to war. I've raised twins. If I had a choice, I'd rather go to war," he has never seen a battlefield.[17]

In 1968, a young George W. Bush found himself days away from eligibility for the draft. Instead, he applied for a spot in the Texas Air National Guard, and despite a considerable waiting list and a dismal score on the pilot aptitude test, he was sworn in immediately. From this perch, Bush and the sons of other well-connected politicians and members of the Dallas Cowboys football team avoided military service in Vietnam.[18] Bush did not even complete his requirement of six years of Guard service. After two years of part-time flight training, he served only 22 of the required 48 months of weekend and part-time duty. During that time, he repeatedly went AWOL and skipped a required annual flight physical. He finally left the Guard in October 1973, the year the draft ended, to attend Harvard Business School.[19]

Many of Bush's most trusted staff members also kept their distance from the front lines. Vice President Dick Cheney, one of the administration's most aggressive war hawks, told a reporter from the *Washington Post* in 1989, "I had other priorities in the '60s than military service."[20] The 25-year-old John Ashcroft was in line to be drafted after his graduation from the University of Chicago Law School, but his family connections got him a job teaching undergraduate business law at Southwest Missouri State University, qualifying him for a civilian deferment.[21] Finally, despite their eagerness to send others to fight and die, neither Karl Rove, John Bolton, Richard Perle, nor Paul Wolfowitz have active military service records.[22]

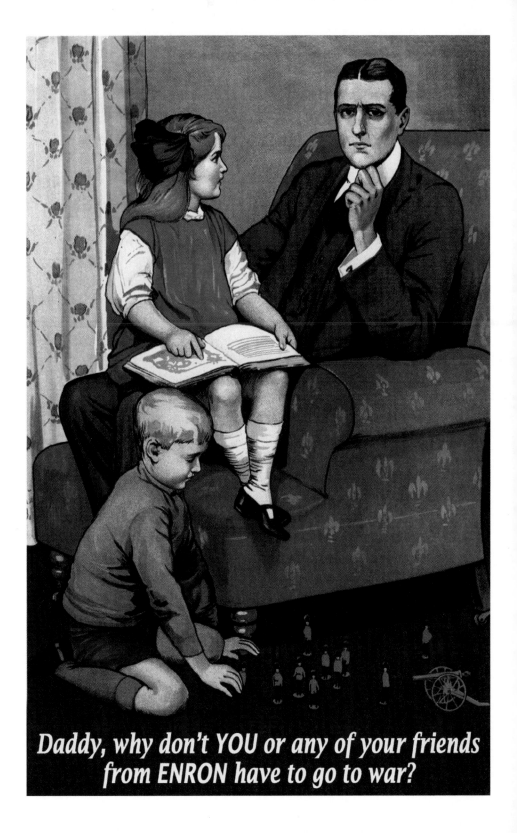

Daddy, why don't YOU or any of your friends from ENRON have to go to war?

In the aftermath of September 11, 2001, conservative organizations and pundits have attacked academics who have criticized the actions of the United States while examining the root causes of terrorism. At the helm of this movement is the American Council of Trustees and Alumni, an organization founded by Vice President Dick Cheney's wife, Lynne Cheney. Its report, entitled "Defending Civilization: How Our Universities Are Failing America and What Can Be Done About It," denounces a number of statements made by professors as "un-American."

This anti–free speech mind-set has been accepted in some universities. For example, one month after the September 11 attacks, professors at CUNY held a forum entitled "Threats of War, Challenges to Peace," which was billed as an opportunity for CUNY professors to discuss the causes and repercussions of the attacks. Notwithstanding the importance historically placed on institutions of higher education as venues for open intellectual discussions of controversial subjects, the *New York Post* responded with a series of articles berating the professors for "America bashing," calling the City College of New York "a breeding ground for idiots." The CUNY administration quickly fell in line behind the *Post*. Chancellor Matthew Goldstein issued a statement of censure against the professors who organized the forum that was later endorsed by the University's Board of Trustees. Though claiming to recognize the importance of "the free exchange of ideas" on CUNY campuses, the trustees called the teach-in "un-American" and "morally seditious," and criticized it for providing a "lame excuse" for the terrorist attacks of September 11.[23]

Incidents like this herald a return to the anti-intellectualism of the Red Scare and the McCarthy era. Once again, academic freedom, to the extent that it manifests itself as criticism of government policy, is being deemed "un-American."

Be A Good American!

DON'T TRY TO THINK!

Never remove your blinders!

A MESSAGE FROM THE MINISTRY OF HOMELAND SECURITY

According to the Convention Against Torture and Other Cruel, Inhuman or Degrading Treatment or Punishment, ratified by the United States in 1994, "[N]o exceptional circumstances whatsoever, whether a state of war or a threat of war, internal political instability or any other public emergency, may be invoked as a justification of torture." According to the *Washington Post*, however, Al Qaeda and Taliban prisoners held at U.S.-controlled Bagram Air Force in Afghanistan have been treated by U.S. forces, the CIA, and the FBI in a way that clearly deviates from this principle.[24]

Prisoners are beaten, blindfolded, bound in painful "stress" positions, and subjected to days of interrogation and sleep deprivation. If the prisoners still refuse to talk, the U.S. purposefully turns over these individuals to law enforcement agencies in countries such as Syria, Jordan, Egypt, Morocco, and Saudi Arabia that are notorious for using torture in interrogation. The results of such brutal interrogation are then handed over to our government, which accepts them with "clean hands." The *Washington Post* quoted one unnamed U.S. official as explaining, "We don't kick the [expletive] out of them. We send them to other countries so *they* can kick the [expletive] out of them." How do our forces get away with breaking international law? According to one Bush administration official, as long as the CIA isn't "in the room," then who is to say they are complicit in torture?

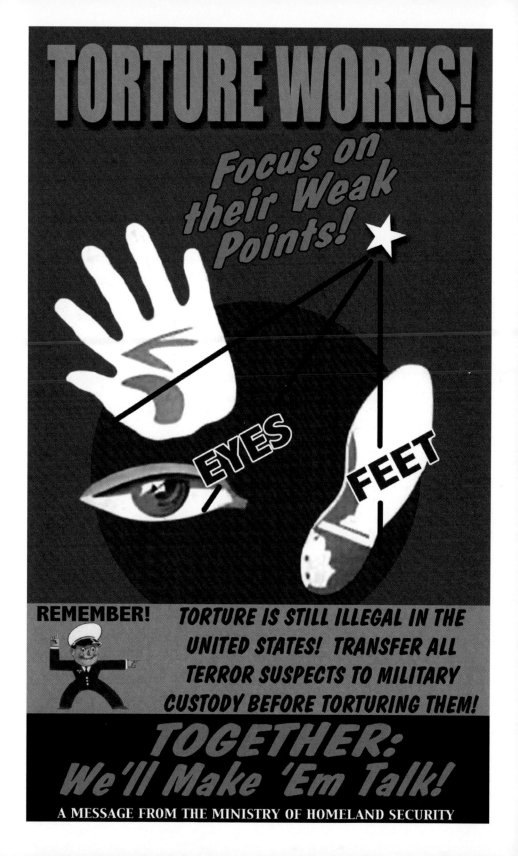

Our First Amendment rights to freedom of speech and freedom of association are two of the most deeply embedded and dynamic of our democratic institutions. Few would disagree that one of the most patriotic things citizens can do is to voice their opinions about our country's policies and actions.

Unfortunately, the Bush administration and the media have attempted to squelch public debate on the issues of the morality and necessity of war with Iraq. Absent from the mainstream media are reports detailing the opposition of American veterans to the war.[25] Nor have we seen press accounts of the Chicago City Council's passage in January 2003 of an Anti-War Resolution by a margin of 46-1 or stories regarding the 60 other American cities and counties that have passed such resolutions as of February 2003.[26] If the Service Employees International Union, Local 1199, had not placed a full-page antiwar advertisement in the *New York Times* in October 2002, would we know about organized labor's opposition to war?[27]

We must also examine why news reports consistently underestimate the size and strength of the peace movement. On October 27, 2002, the *New York Times* published an article reporting that the turnout at an antiwar demonstration in Washington, D.C., the day before was only in the "thousands" and was "below expectations." Only after a tremendous outcry from activists did the *Times* publish an article that corrected the record. The resulting October 30, 2002 article, "Rally in Washington Is Said to Invigorate the Antiwar Movement," acknowledged that the demonstration in Washington "drew 100,000 by police estimates and 200,000 by organizers," and formed a two-mile wall of marchers around the White House, well above the organizers' expectations.

Meanwhile, the political arena has produced a hellbroth of policies designed to instill fear in people who wish to speak their minds. For example, the FBI has enlisted university campus police in its effort to infiltrate and spy on college student organizations—a tactic used during J. Edgar Hoover's notorious 15-year COINTELPRO program to monitor and disrupt student activist groups. Policies like these tear the fabric of our society—rending the institutions that keep democracy alive in this country.

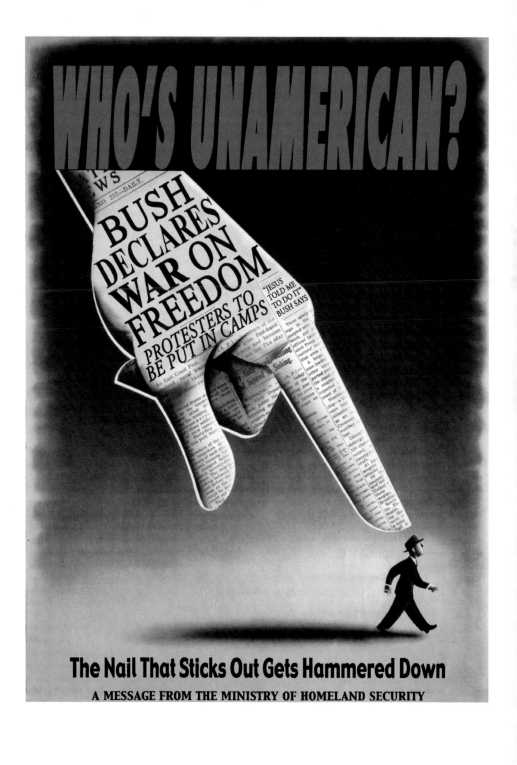

S ince the September 11 attacks, the U.S. government has gone to tremendous lengths to hide its actions from scrutiny by the press, the public, Congress, and the courts by citing an increased need for security. On September 21, 2001, Chief Immigration Judge Michael Creppy issued a directive blocking the press and the public from attending the immigration hearings of Muslim and Arab noncitizens that the INS had placed under arrest following the attacks. Outraged by this effort to block its investigation into why more than 1,000 noncitizens of Muslim and Arab nations with no apparent ties to terrorism were being detained by the INS, two sets of newspapers—one in Michigan and the other in New Jersey—filed lawsuits challenging the constitutionality of the Creppy directive.

In August 2002, a federal court of appeals ruled for the press in the Michigan case, holding that the press has a First Amendment right to attend immigration hearings except in individual situations where the government is able to demonstrate to the immigration judge that closure is necessary for national security reasons. As Judge Damon Keith, the author of this opinion, explained, "Democracies die behind closed doors.... When government begins closing doors, it selectively controls information rightfully belonging to the people. Selective information is misinformation."

Three months later, however, a different federal court of appeals ruled for the government in the New Jersey case. This court refused to examine the credibility of the security claims offered by the government in support of the Creppy directive, even though it realized that these claims were speculative. Concluding that "national security is an area where courts have traditionally extended great deference to Executive expertise," the court simply deferred to the government. Given this split of opinion between two appellate courts, the Supreme Court is likely to have the last say on this issue.

When the executive branch operates in secrecy and the courts relinquish their constitutional authority to act as a check on its abuse of power, there is no one left to monitor the integrity of, or the necessity for, its actions. Under these circumstances, our civil liberties can easily fall victim to measures that the government claims—with or without substantiation—are required to protect the national security.

**PATRIOTISM
MEANS
NO QUESTIONS**

A MESSAGE FROM
THE MINISTRY OF
HOMELAND SECURITY

On September 20, 2002, the Bush administration outlined a new "preemptive strike" doctrine under which U.S. military force could be used against any state that the administration perceives as hostile. This doctrine violates the terms of the United Nations Charter and fundamental international law principles. The UN Charter, a treaty of the United States ratified by almost every country in the world, prohibits the use of force by one country against another except in two situations: in the case of self-defense and in the case of UN Security Council approval.

Article 51 of the UN Charter sets forth an exception to the use of force for self-defense "if an armed attack occurs" or in response to an imminent attack.[28] No one, not even President Bush, asserts that either of these conditions exists with respect to Iraq. In fact, in his State of the Union address in January 2003, Bush clearly stated his disagreement with those who "have said we must not act until the threat is imminent," arguing that by then, it would be too late.[29]

Nor is a war against Iraq legal under the exception for UN Security Council approval and authorization.[30] On November 2, 2002, the Security Council approved a resolution regarding an enhanced inspection regime for Iraq, but that resolution does not authorize the use of force.[31] Nor does the resolution grant the United States the right to determine that Iraq is in "material breach" of its inspections obligations. Moreover, the resolution does not authorize the United States to decide what to do in the case of such a breach but leaves decisions as to the use of force to the Security Council as a whole. The Bush administration simultaneously argued that the United States does not need authority from the UN to go to war, and that Resolution 1441 provided it that authority. But the absence of a prohibition is not a grant of authority.

This U.S. violation of international law on the use of force sets a very dangerous precedent. What if India, Israel, Pakistan, and North Korea, each of which has nuclear capabilities, were to follow suit? The Bush administration's lack of respect for the protections that bind the international community make us all more vulnerable to preemptive military actions.

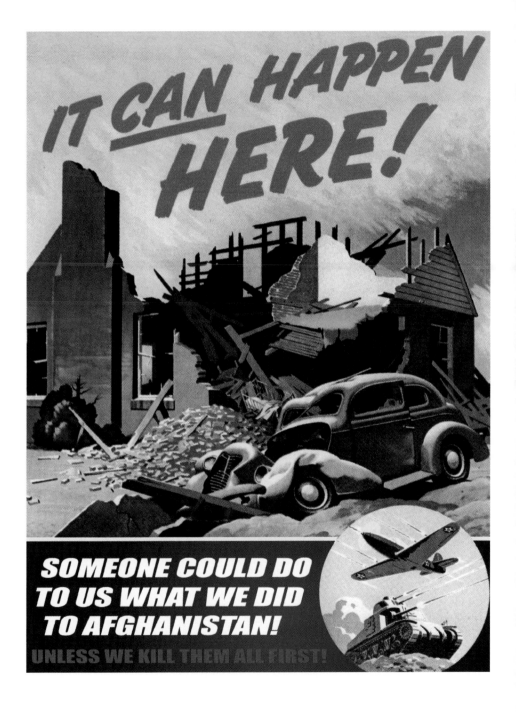

The defense industry has seen a considerable return on its investment of $8.7 million in campaign contributions to the Republican Party during the 2000 Presidential election.[32] And President Bush has shown his gratitude by increasing the military budget for fiscal year 2003 by $45.3 billion, the largest single increase since 1966. The dollar value of this increase alone exceeds the individual military budgets of every other country in the world with the exception of Japan. The total U.S. military budget for fiscal year 2003 will be $396.1 billion, 26 times larger than the combined military budgets of the countries considered "rogue states" by administration officials: Cuba, Iran, Iraq, Libya, North Korea, Sudan, and Syria.[33] The dimensions of this military budget will ensure the profitability of the defense industry that donated to the Bush campaign. While global stock markets were spiraling downward in the aftermath of September 11, the value of several major defense companies increased by at least 25 percent and continued to rise throughout most of 2002.[34]

The defense industry is not the only part of the business sector that stands to profit from this most recent exercise of American military might. The energy industry may also see a nice return on its $2.8 million contribution to the Republican Party in 2000.[35] Iraq has 115 billion barrels of oil reserves, the second largest in the world next to Saudi Arabia. It also has the largest number of unexplored oil fields in the world.[36] Many countries, such as Russia, France, Vietnam, and Syria, already have contracts with Saddam Hussein's government for exploration of these regions.[37] A new Iraqi government installed by the U.S. could revoke these contracts and award them to the highest bidder.

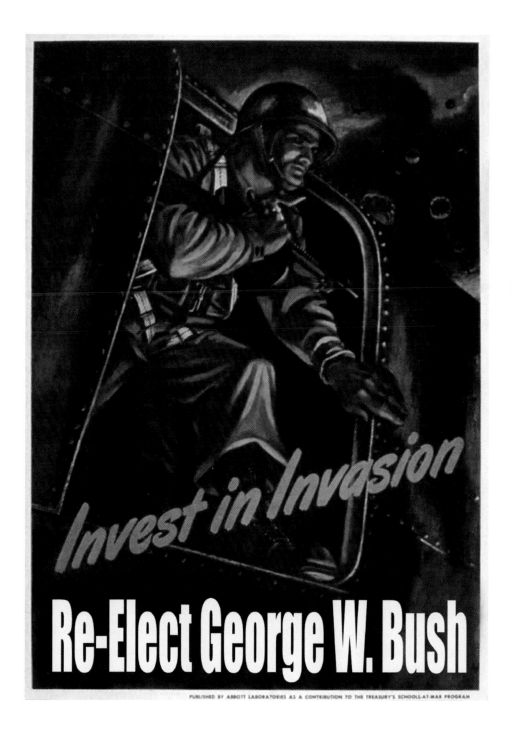

Invest in Invasion

Re-Elect George W. Bush

PUBLISHED BY ABBOTT LABORATORIES AS A CONTRIBUTION TO THE TREASURY'S SCHOOLS-AT-WAR PROGRAM

In some respects, military officers currently have more say over the legality of certain detentions than courts do. One exemplary case is that of Yaser Hamdi, a U.S. citizen (born to Saudi parents) who surrendered with his Taliban unit and was shipped (via Guantanamo) to a military brig in South Carolina. His father challenged the detention in court. The government asked the court to engage in very limited review, but the court went further than even the government had suggested, holding that because Hamdi was captured in a zone of active combat overseas, and the executive had determined—in its sole, unreviewable discretion—"that [Hamdi] was allied with enemy forces," he could be kept in solitary confinement until the president declares the open-ended war over.

Why such a limited review? The court claimed its exceptional deference to the military was justified because "any [judicial] inquiry must be circumscribed to avoid encroachment into the military affairs entrusted to the executive branch." This sort of blanket deference has become commonplace in the post–September 11 military detainee opinions. The underlying premise is that courts, by placing upon the government any kind of burden to produce proof that a battlefield detainee was fighting against our forces in a way that disqualifies him from POW status, would unduly hinder the ongoing conduct of war by requiring that field commanders neglect their duties in order to give evidence. In reality, the modern military is set up to operate within the bounds of today's increasingly refined notions of the law of war, and as a result it is well equipped to deal with the demands of legal process. In the 1991 Gulf War, for example, the military had 250 lawyers near the front lines to approve choices of targets, and hold hearings to sort out the status of civilian and POW captives.

If the courts continue to abdicate their constitutional role of reviewing the executive's account of the facts, career military officers and "experts," not elected officials or their direct appointees, will have the final say over these detentions. Are we, as Americans, comfortable with giving the military this unchecked power to hold a citizen in solitary confinement, half a world away from the field of battle, long after active hostilities have ceased?

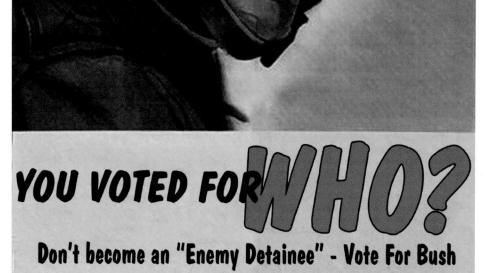

YOU VOTED FOR *WHO?*

Don't become an "Enemy Detainee" - Vote For Bush

A MESSAGE FROM THE MINISTRY OF HOMELAND SECURITY

When comedian Bill Maher quibbled with Bush's description of the hijackers as "cowards" by commenting, "Staying in the airplane when it hits the building–say what you want about that, it's not cowardly," White House Press Secretary Ari Fleischer angrily warned that Americans need "to watch what they say."[38]

Fleischer's remark was soon followed by that of our nation's top law enforcement officer, Attorney General John Ashcroft, who testified before the Senate Committee on the Judiciary that "those who scare peace-loving people with phantoms of lost liberty...your tactics only aid terrorists, for they erode our national unity and diminish our resolve," and "[t]hey give ammunition to America's enemies and pause to America's friends."[39]

As chilling as these warnings may be, most Americans still refuse to equate dissent with a lack of patriotism. On February 15, 2003, an estimated half million demonstrators converged on New York City, to protest the Bush administration's plans to attack Iraq. These demonstrators, along with many others who joined them in protests held that day in cities across the United States, sent a message to the world: Americans will follow their consciences and speak their minds.

Hunger is inexcusable in the modern world. But 20 years of armed conflict followed by years of severe drought have devastated Afghanistan's ability to produce food. The World Food Program, the United Nation's frontline food aid organization, has recently estimated that 7.5 million Afghanis are malnourished, nearly one in four of whom are children under five years of age. During the months of October and November 2001, American bombing of the Afghani countryside limited the amount of food that could be delivered to 13,000 tons per month—far short of the 52,000 tons needed per month.[40] The amount of food rations that the U.S. government has airdropped into Afghanistan is estimated to be only a tiny fraction of that needed to feed Afghanistan's hungry. To make matters worse, many of these rations were untouched because their yellow packaging closely resembled the unexploded cluster bombs also dropped by U.S. planes. In addition, many of these rations have been dropped into heavily land-mined areas, and people would have to risk dismemberment or death to retrieve them.

In Iraq, more than 500,000 children have died from malnutrition or a lack of medical attention since the U.S.-imposed economic sanctions upon that country following the 1991 Gulf War. Denis Halliday, the former United Nations coordinator of an oil-for-food program that permits Iraq to sell limited amounts of oil to buy food and medicine, blasted the sanctions policy as a "totally bankrupt concept" that "doesn't impact on governance effectively and instead damages the innocent people of the country."[41] The U.S. attack on Iraq will have dire consequences on Iraq's population, including an increase in starvation and disease.

And at home, funding the military buildup has taken precedence over feeding the impoverished. While the U.S. military machine is stoked, the government has called a unilateral withdrawal from the "war on poverty." Under the guise of welfare reform, the number of people living in poverty who receive subsistence benefits has been slashed as their ranks have swelled from a rise in unemployment. In a nation where we pay farmers not to grow food, millions go hungry.

This man's willingness to open fire on a crowd of American demonstrators probably means that his M-1 is loaded with rubber bullets, one of the many "nonlethal" weapons that are currently being used by the U.S. military and local police departments. The Department of Defense operates a "nonlethal technologies" program that, Pentagon officials say, offers a range of crowd control options falling in between the extremes of shooting a lethal weapon and taking no action.

While these technologies purport to be nonlethal, they can cause serious injury and death. According to the Defense Science Board, an independent panel of advisors to the Pentagon, "a usually non-lethal weapon may cause unintended lethality under certain conditions: a stun gun could kill someone with a weak heart. A 'rubber' bullet could hit a particularly vulnerable body part like the throat..."[42]

First used in 1960s, the rubber bullet has remained a popular choice at protests, although its use was discontinued from 1971 to the late 1980s due to a fatality.[43] One of the most popular of these projectiles is actually metal, but it is coated with rubber to keep it from penetrating the skin. Studies have shown that rubber bullets can maim and even kill when they are fired at close range or hit the torso region instead of the legs. "Nonlethal" weaponry was used against protesters at the WTO protests in Seattle in 1999 (rubber bullets, batons, tear gas, pepper spray, concussion grenades),[44] the 2000 Democratic National Convention in Los Angeles (pepper spray, tear gas, rubber bullets, batons),[45] the IMF and World Bank protests in the spring of 2000 in Washington, D.C. (rubber bullets, tear gas, pepper spray, batons),[46] an anti-Bush protest in Portland, Oregon, in August 2002 (batons, pepper spray, bean-bag rounds, and rubber bullets),[47] and many others.

New "nonlethal" crowd dispersal technologies make even the rubber bullet seem safe. Among the weapons already in the U.S. arsenal or under development are: low-frequency sound generators that incapacitate by causing nausea and disorientation; "sticky foam" to immobilize an individual; Teflon-type lubricants that make a hard surface so slick that it is virtually impossible to stand or move while on it; and microwave transmitters that heat the surface of the skin to the point of unbearable pain.[48] How long will it be before these new weapons are used routinely on peaceful protesters

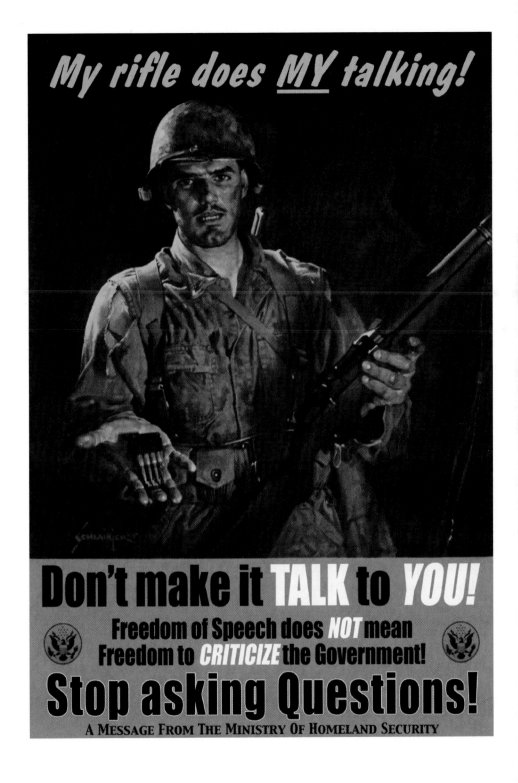

*F*ahrenheit *451*, Ray Bradbury's cautionary 1953 novel about a future society that burned books because they were full of "dangerous" ideas, was published in the midst of a period of fierce suppression of speech. People were fired from their jobs or sent to prison based on tips from thousands of informants that they had attended certain meetings or read certain books.

This time, the government has made it far easier to single out and punish those who seek out the voices of dissent. The USA PATRIOT Act's Section 215 amended the existing provisions of the Foreign Intelligence Surveillance Act to allow the FBI to seize such things as circulation records from libraries and purchase records from bookstores, without having to show that the target's records are linked in any way to criminal activity; all the FBI needs to do is swear before a secret court that the request is for "an authorized investigation...to protect against international terrorism or clandestine intelligence activities." Under the PATRIOT Act, the FBI never tells the person being investigated that the information has been sought or gathered, and the library or bookstore is forbidden to tell anyone of the FBI's demands for, and seizure of, these records. In fact, the FBI will not even say how many of these demands it has made in the period since the PATRIOT Act was passed.[49]

The PATRIOT Act scheme sounds like the scary science fiction of *Fahrenheit 451*. Deplorably, it is fact. Our government has given itself the extraordinary authority to monitor our thoughts. To ensure that we remain free to express and share our ideas, we must fight to stop such intrusions on our fundamental rights.

BOOKS
CAUSE
DANGEROUS
THOUGHTS

FOR YOUR PROTECTION
GIVE ALL BOOKS
TO YOUR LOCAL FIREMAN
FOR SAFE DISPOSAL

A MESSAGE FROM THE MINISTRY OF HOMELAND SECURITY

The First Amendment to the U.S. Constitution protects "the right of the people peaceably to assemble" and "to petition the government for a redress of grievances." However, if you try exercising this right anytime near wartime, the government and the press may assume that you come armed with more than words.

A few months after September 11, 2001, in an effort to show its solidarity with New York City, the World Economic Forum held its annual meeting in that city. Antiglobalization protesters planned a large demonstration for the weekend of this elite gathering. Despite clear statements by organizers that the protest would be peaceful, the demonstrators were compared to terrorists by the press. The *New York Post* ran a column entitled "Econ Summit Brings Own Terror Threat" in which former New York City deputy police chief John Timoney worried about protesters whom he considered to be "very serious bad guys...and I'm not talking about Osama bin Laden."[50] Similarly, a *Daily News* editorial warned protesters, "New York will not be terrorized."[51] There was no evidence that violence was planned to support these fevered statements, which seemed intended to deter people from speaking their minds.

This chilling trend continues. Two days before the first anniversary of the September 11 attacks, the *New York Times* advised the public to be wary of potential terrorist strikes in an article titled "F.B.I. Warns Local Agencies to Be Aware."[52] Not only did the *Times* report a potential for "heightened terrorist activity" on September 11, 2002, but, in the same article, the *Times* also cautioned residents that the upcoming meetings of the World Bank and the International Monetary Fund were to be regarded as "potential targets for terrorism," since protests against the organizations were being planned by "a loose alliance of left-wing groups" with "a history of causing property damage." When political protest is equated to terrorism, the First Amendment is in serious jeopardy.

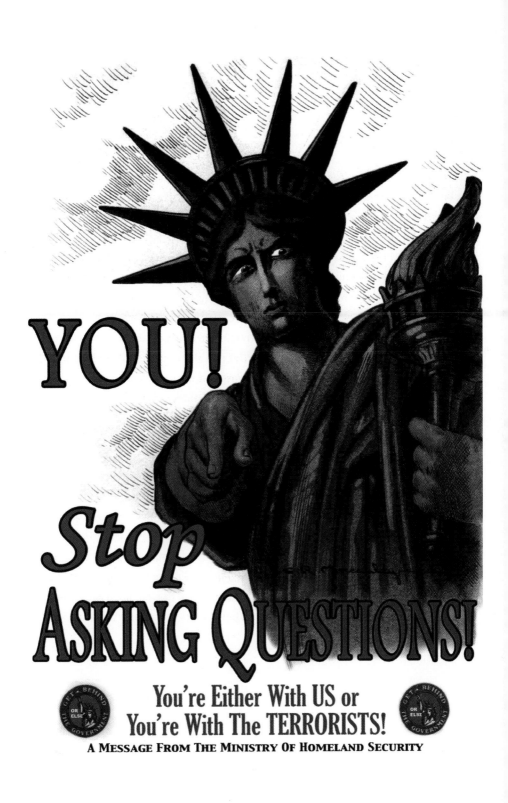

W ithin hours of the September 11 attacks, the FBI, in cooperation with the INS and local police departments, sent out a dragnet that soon rounded up more than a thousand Muslim men from Arab and South Asian countries. These detainees were held for periods ranging from a few days to in excess of a year—often on the pretext of minor immigration violations—with little or no access to families, attorneys, consular officials, or public interest organizations, and with little or no regard for their constitutionally protected right to due process of law. Many of them suffered severe physical and psychological abuse while they were imprisoned.

When we look at the reasons they were picked up, we see that these men were targeted by the government based on their ethnicity and religion rather than on individual suspicion of their engagement in any criminal or terrorist activity. Some came to the attention of law enforcement agents in the course of traffic stops and other chance encounters, while others were reported to law enforcement authorities by neighbors and acquaintances who found their Middle Eastern "appearance" suspicious.[53] Not one of them has been charged with, much less convicted of, any crime relating to the September 11 attacks.

The mass arrests, which have continued to the present, are eerily reminiscent of the detention of 110,000 individuals of Japanese descent following the bombing of Pearl Harbor on December 7, 1941. On February 19, 1942, President Franklin D. Roosevelt's Executive Order 9066 mandated the evacuation, relocation, and internment of the 110,000 Japanese-American citizens and Japanese resident aliens living on the West Coast. These people remained imprisoned during much of World War II even though they did nothing to support Japan in its war effort. When we do not learn from our past mistakes, we are doomed to repeat them.

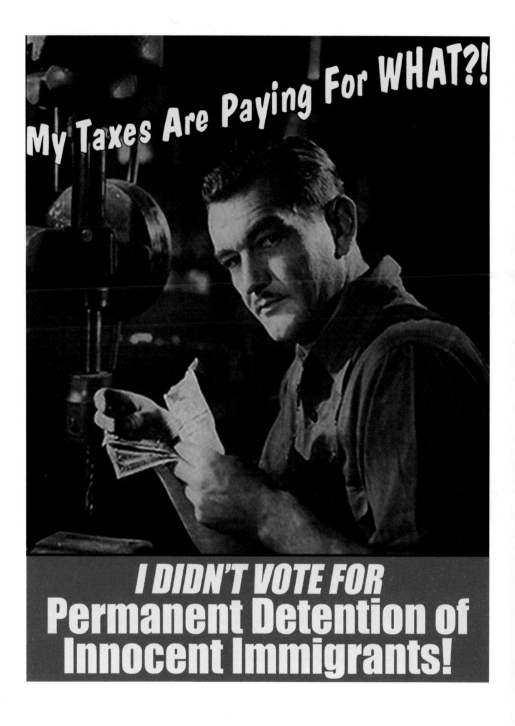

In 1966, Congress passed the Freedom of Information Act (FOIA), a law that implements "a general philosophy of full agency disclosure" by providing the public with broad access to federal government records. Shortly after assuming office, President Bill Clinton sent a memo to all federal agency heads encouraging them to be responsive to FOIA requests. Affirming the intrinsic value of a well-informed American public, President Clinton stated:

> [FOIA] was based upon the fundamental principle that an informed citizenry is essential to the democratic process and that the more the American people know about their government the better they will be governed. Openness in government is essential to accountability and the Act has become an integral part of that process.[54]

The Bush administration, however, has taken a 180-degree turn from the course charted by President Clinton, opting instead to keep the American public in the dark about many of its activities. An October 2001 memorandum sent by Attorney General Ashcroft to federal agency heads discourages them from releasing information requested under FOIA by promising:

> When you carefully consider FOIA requests and decide to withhold records, in whole or in part, you can be assured that the Department of Justice will defend your decisions unless they lack a sound legal basis or present an unwarranted risk of adverse impact on the ability of other agencies to protect other important records.[55]

While we might like to trust our government to do the right thing, the reality is that misconduct thrives under conditions of secrecy. The best hope for a government of the people, by the people, and for the people is an open government.

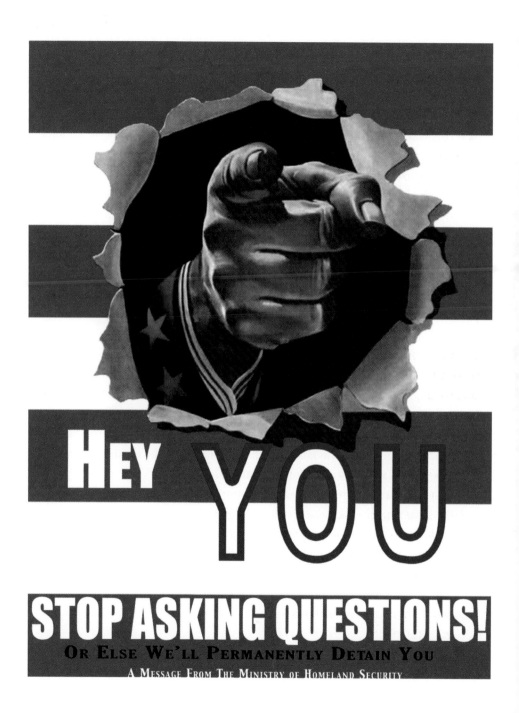

ermann Goering, Hitler's second in command, recognized, "Naturally the common people don't want war. But, after all, it is the leaders of the country who determine the policy and it is always a simple matter to drag the people along. All you have to do is tell them they are being attacked, and denounce the peacemakers for lack of patriotism and exposing the country to danger. It works the same in any country."

Goering's cynical observation is not confined to Nazi Germany. At an October 11, 2001, press conference, President Bush called Afghanistan "the first battle in the war of the 21st century." According to Bush, "[our] enemies view the entire world as a battlefield, and we must pursue them wherever they are." He has already proclaimed that the "campaign may not be finished on our watch."

As historian Howard Zinn pointed out in February 2002, "There was no chance from the beginning that we could 'win' a war on terrorism because terrorism is...a phenomenon that can spring from any country in the world where there are people who are angry at the United States."[56] "Terrorism" is not restricted by region or ideology. The horror of the September 11 attack has allowed our leaders to ignore the recent role of the U.S. government in training and supporting terrorists, such as the contras in Nicaragua, the mujahedeen in Afghanistan, the death squads in El Salvador, and the anti-Castro faction in Miami.

The new and endless war does not start outside our borders. The government would convince us that our enemies are not only those who oppose our policies abroad, but also those who oppose them at home and those who are nationals of Middle Eastern and South Asian countries. As long as we are at war with amorphous enemies, the government can always claim that it is justified in asking its citizens, in the name of national unity, to sacrifice their freedoms and shut their eyes to the expansion of American military might.

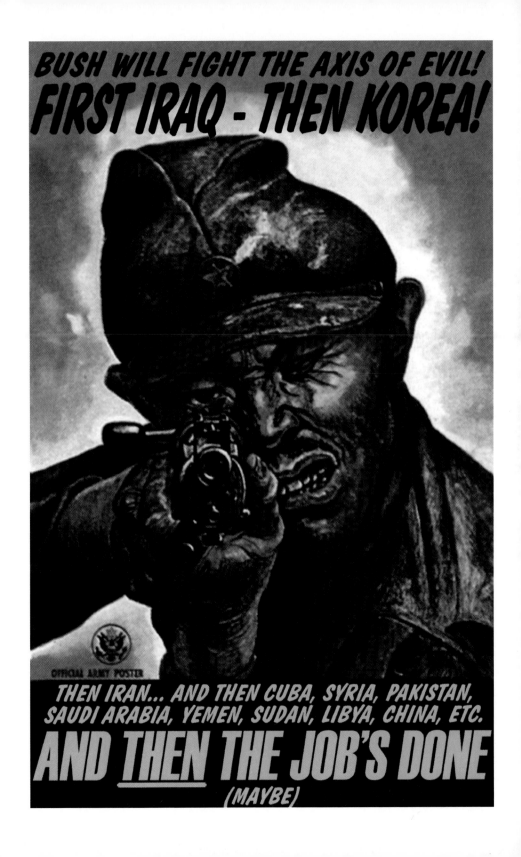

The Posse Comitatus Act of 1878 was passed by Congress to end the Army's police role in the South and the West, where soldiers were used to enforce local laws that were intended to undo the institutions of slavery after the Civil War. The act sharply restricts the military's ability to participate in domestic law enforcement by preventing it from exercising police powers or arresting civilians. It is now viewed as one of the primary protections against the development of a military so powerful that it could threaten our democracy.

But during the summer of 2002, Homeland Security Chief Tom Ridge announced that he was asking government lawyers to review the Posse Comitatus Act because the federal government was considering the use of troops to engage in local law enforcement activities. These changes would turn the policy behind the Posse Comitatus Act on its head, allowing military power intended to repel external aggression to be instead used internally against the people of our country.

Other Bush administration policies also serve to radically undermine our civil liberties and tear great rifts in our diverse communities and institutions. Collaborative arrangements between the INS and a number of local police departments—taken in the name of national security—have already engendered fear in our immigrant communities. As a result of these arrangements, immigrants are increasingly hesitant to call for assistance from government agencies even when they are the targets of racial and religious discrimination or fall victim to crime and catastrophe.

Our military—indeed, the whole of our government—was intended to serve and defend our principles of freedom and equality. It cannot do so while simultaneously dismantling these ideals.

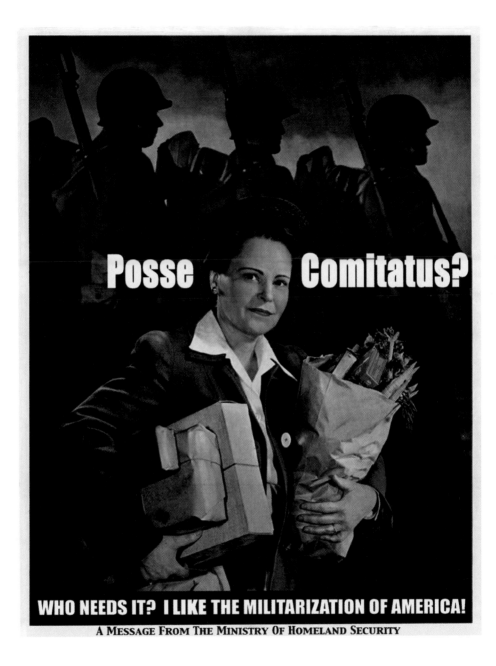

While we sleep and go about our other activities of daily life, the Department of Defense is developing the technological ability to collect information on those activities—our credit card purchases, including our online book and movie ticket purchases, airline and hotel reservations, and car rentals; our banking and financial transactions; our tollbooth records; our school records; our marriages and divorces; and our telephone and Internet usage, to name just a few—and to store this information in "a virtual, centralized grand database" so that it can be searched for persons whose activities seem suspicious.[57]

The logo of this project, dubbed Total Information Awareness, is an all-seeing eye perched above a pyramid with the motto "knowledge is power" inscribed in Latin. As if that were not disturbing enough, the direction of the project has been entrusted to a shadowy figure from the administration of President Ronald Reagan, Rear Admiral John Poindexter. As National Security Advisor, Poindexter applied proceeds from the sale of arms to Iran to fund the contra rebels in Nicaragua. His felony convictions stemming from these actions were overturned on appeal only because Congress had granted him immunity in exchange for his testimony.

Hopefully, Congress will nix TIA before it goes into full operation. If it fails to do so, Big Brother will be getting quite a peep show into our lives.

Total Information Awareness:

Sleep Easy Citizen...
Big Brother is Always Watching

n its original form, this poster warned Americans to keep secrets from the country's enemies. It now speaks of government censorship. When wars are fought abroad, the public must rely on the press for important information on the success of the endeavor, and on the resulting casualties. To accurately report on war, reporters must have access to the battlefields themselves. The U.S. government continues to limit this access.

During World War II and the Vietnam War, correspondents had broad access to the war front, allowing them to report details of battles they had personally witnessed. Without question, the public's exposure to the brutality of the Vietnam War, including photos of napalmed Vietnamese children, was instrumental in building American opposition to that war.

Since the Vietnam War, the government has restricted reporter access to the front lines. When the U.S. military invaded Grenada on October 25, 1983, reporters were banned from the island for three days.[58] The several reporters who got to Grenada on their own before the invasion started were detained on board a Navy ship for the duration of the three-day blackout. By blocking the only reporters who had witnessed the invasion from filing reports, the sole source of information available to the public consisted of official government reports. In response to criticism over the lack of press access in Grenada, the Pentagon created a National Media Pool of news organizations.[59] The "pool" is activated or deactivated at the command of the military, which sets ground rules for participation and strict limits on publications. During the 1989 invasion of Panama, the first Bush administration used the "pool" system to control reporters without giving them access to the front lines of conflict until the fighting was almost over. Journalists were forbidden from interviewing Panamanian prisoners or injured American soldiers. The first Bush administration also relied on the "pool" system to control press access during the 1991 Gulf War. Even when journalists are given access to the battlefield, as in the case of the embedded reporters in Iraq, their ability to convey the accounts of their choice is severely compromised.

As the sanitized images from Iraq attest, U.S. military control over reporter access will shield the American people from exposure to the gruesome realities of war.

With the U.S. Attorney prosecuting "dirty bomber" José Padilla and claiming that "anyone who aids or abets terrorism" is an "enemy combatant," and with John Ashcroft saying that those "who scare peace-loving people with phantoms of lost liberty...only aid terrorists," a lot of civil liberties organizations might qualify as terrorist-aiding "enemy combatant" groups. Luckily, the government isn't plagued by a need for consistency in its "enemy combatant" designations. Compare, for example, the treatment of confused young Taliban hanger-on John Walker Lindh and confused young Taliban hanger-on Yaser Esam Hamdi. The first, a white U.S. citizen, was allowed a lawyer, charged, and got a plea bargain; the second, a U.S. citizen born to Saudi parents, has been sealed in a military brig with no contact with the outside world since early 2002.

The amusing thing about this poster's caption is the legalistic phrase "punishable by permanent, illegal detention": since "punishable" implies legality, it's a non sequitur. The paradox only makes sense if you understand that our courts have held that they have no power over what the government does at Guantanamo Bay. Under the literal terms of the perpetual lease we signed in 1903 with our then-colony Cuba, we have total power over Guantanamo, but Cuba retains "technical sovereignty." The courts have held that this legal technicality trumps the de facto sovereignty we exercise there, and that therefore noncitizens held by the government have no right to appeal the legality of their detention to our courts. British courts have thus described Guantanamo Bay as a "legal black hole," and the Inter-American Commission on Human Rights has said the detainees are being held "entirely at the unfettered discretion of the United States government"—with no court to complain to even if their detentions are clearly illegal.

Similarly, the Geneva Convention provides all sorts of very specific minimum rights to prisoners of war (such as the right to contact one's family, and to have visits from the Red Cross), but recently our courts have held that none of these provisions are "self-executing"—that is, they cannot be enforced in court. The Constitution characterizes treaties as "the supreme Law of the Land," but apparently not all laws are created equally.

So how can we determine if a detention is illegal in a place without law?

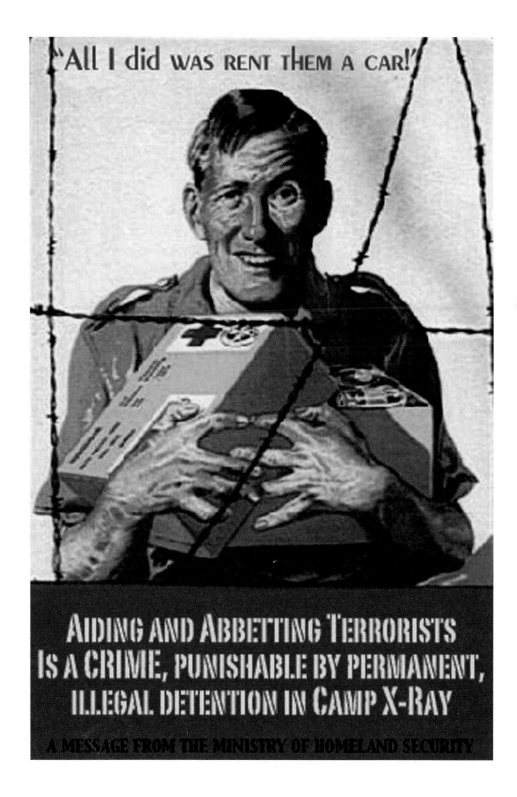

Two months before launching "Operation Iraqi Freedom," President Bush, in his January 2003 State of the Union speech, virtually declared war against Iraq. To convince Americans to "back the attack," Bush presented a history lesson on how "the will for free peoples" and the "might of the United States" had defeated "Hitlerism, militarism, and Communism." But Bush's comparison of Iraq to Germany and the Soviet Union is fatally flawed. At the outbreak of World War II, Germany was the most powerful industrial nation in the world. During the Cold War, the Soviet Union, whose army was the largest in the world, kept nuclear weapons trained at the United States. The Iraq that has emerged from the 1991 Gulf War, however, has little in the way of offensive military capacity.

The world is united in condemning Saddam Hussein for his atrocious human rights record, including his use of torture. But President Bush is disingenuous when he cites this record as a basis for an American attack on Iraq. The U.S. does not bomb, or even condemn, other countries because they engage in human rights violations. To the contrary, since September 11, 2001, the U.S. has knowingly accepted information extracted from suspected terrorists by intelligence agencies in Egypt, Jordan, Morocco, and other countries that routinely torture prisoners.

Is this war against Iraq simply about the regime of Saddam Hussein, or is it about our access to Iraqi oil, our dominance in the Middle East, and the building of an American empire?

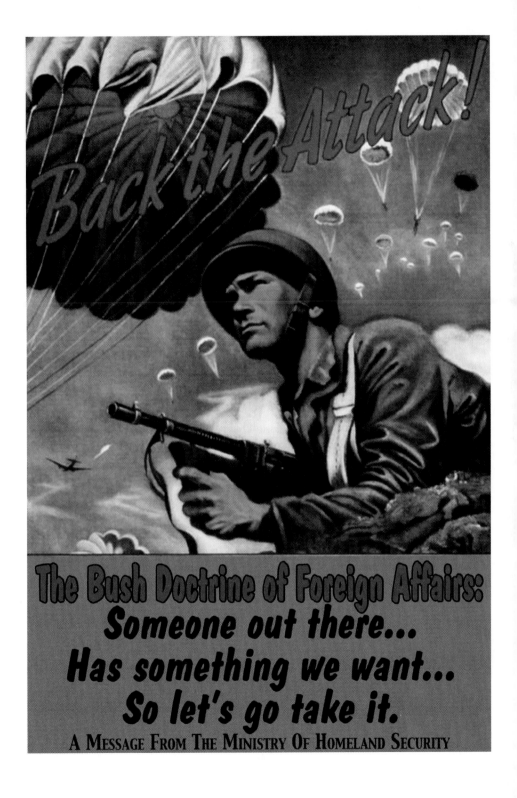

Journalistic freedom suffered a serious blow after the September 11 attacks. Dan Guthrie, an award-winning journalist for the *Grants Pass Daily Courier* in Oregon, was dismissed for writing a column entitled "When the Going Gets Tough, the Tender Turn Tail," in which he accused Bush of "hiding in a Nebraska hole" on September 11.[60] In a similar scenario, Tom Gutting of the *Texas City Sun* was fired for writing a column in which he accused Bush of "flying around the country like a scared child" on September 11. Guthrie's and Gutting's publishers added insult to injury by running front-page apologies to their readers for having printed these columns.[61]

These days, journalists who report stories critical of the government and express controversial viewpoints do so with the understanding that they may find themselves jobless and branded as unpatriotic to boot. Even CBS's Dan Rather, one of America's most popular news anchors, admitted to the British press in May 2002 to having experienced the "fear that keeps journalists from asking the toughest of the tough questions."[62]

Most of us depend upon the press to inform us as to what is going on in the world. But what if the press isn't free? Self-censorship by the press is every bit as real, and every bit as dangerous to our democracy, as censorship imposed by the state.

YOUR pen... an enemy weapon?
Not if you keep your criticism
of George Bush to *YOURSELF!*

A MESSAGE FROM THE MINISTRY OF HOMELAND SECURITY

Leaders of the United States beware: the use in Iraq of the anticivilian tactics used in campaigns in Afghanistan, Kosovo, and in the 1991 Gulf War may violate International Humanitarian Law (IHL) and could subject you to treatment as war criminals.

IHL does not outlaw war per se, but it attempts to minimize, to the maximum extent possible, the adverse impact of armed conflict on civilian lives and infrastructure. It places constraints on the conduct of hostilities and prescribes that all feasible precautions are taken in the choice of means and methods of attack to protect civilian life. Most of the laws are grounded in the Geneva Conventions, treaties ratified by the U.S. in 1950, or in customary international law. IHL prohibits not only direct attacks against civilians and civilian infrastructure, but also the planning and execution of attacks that fail to adequately distinguish between military targets and civilian ones, and attacks that, though aimed at military targets, cause excessive civilian casualties.

Several means and methods of attack used during recent armed conflicts in which U.S. armed forces participated violate IHL. These actions included high-level and indiscriminate air strikes on known centers of civilian population; carpet bombing; fuel-air explosives and cluster bombs; excessive targeting of electricity supplies, causing damage to civilian facilities reliant upon such supplies, including water supply and treatment facilities and hospitals; bombing of works or installations that contain "dangerous forces," namely, dams, dykes, and nuclear electrical generating stations; and bombing specifically aimed at terrorizing or undermining the morale of civilians or that is designed to overthrow an existing government.

In a January 24, 2003, letter to President Bush, a group of law professors and non-governmental organizations documented specific occurrences of the above-described illegitimate means and methods of attack during U.S. military actions in the 1991 Gulf War, in Kosovo in 1999, and in Afghanistan in 2001. Some of the violations of IHL committed during these conflicts may also have constituted international crimes for which the individuals responsible, including senior government figures, may be held personally accountable.

Were IHL principles so much as considered by the Pentagon when it dreamed up its cataclysmic Operation Shock and Awe?

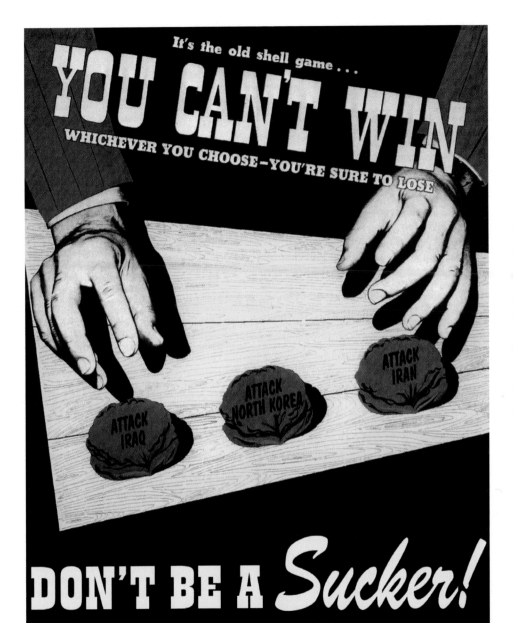

At the same time the Bush administration condemns Saddam Hussein and others for allegedly possessing weapons of mass destruction, it has set back the debate on nuclear disarmament by three decades. In December 2001, the United States backed out of the Anti-Ballistic Missile Treaty, a treaty designed to curb the proliferation of nuclear weapons, claiming that the treaty hinders the United States' ability to defend its citizens from terrorists and rogue states. In a clever twist of logic, the Bush administration has portrayed its unilateral offensive action as a defensive move in anticipation of a potential attack.

Representative Dennis Kucinich and 31 other members of the House of Representatives challenged the President's power to withdraw from treaties without consulting the Senate. The representatives argued that, under the Constitution, the Senate must ratify treaties, and that allowing the president to unilaterally cancel treaties without the approval of the Senate would destabilize foreign relations by making each presidential election an opportunity to undo all of our agreements— even long-term multilateral ones—with other nations. The D.C. district court, however, dismissed this suit without reaching the merits in December 2002, concluding that this matter should be resolved by the executive and legislative branches through the political process.

Additionally, the Department of Defense is seeking to develop "low-yield" nuclear weapons, or "mini-nukes," for use in everyday warfare. These weapons are designed to penetrate reinforced concrete bunkers and then to destroy whatever or whomever happens to be inside the bunker. These weapons completely change previous notions of nuclear weaponry. In the midst of the Cold War, nuclear weapons were considered a deterrent, not intended for use. If the United States were to begin using nuclear weapons, even small ones, against its enemies, other nations could easily follow its example, with catastrophic consequences. This, in part, explains why Congress banned the development of any new low-yield nuclear weapons in 1994. In an attempt to avoid the ban, the Department of Defense has claimed that it is simply refurbishing existing weapons.

The Bush administration is encouraging a dangerous nuclear trend. India and Pakistan already threaten to use their nuclear arsenals against each other. North Korea recently withdrew from the Nuclear Nonproliferation Treaty. This, taken together with other developments, means that the threat of nuclear war is greater than it has been since the end of the Cold War.

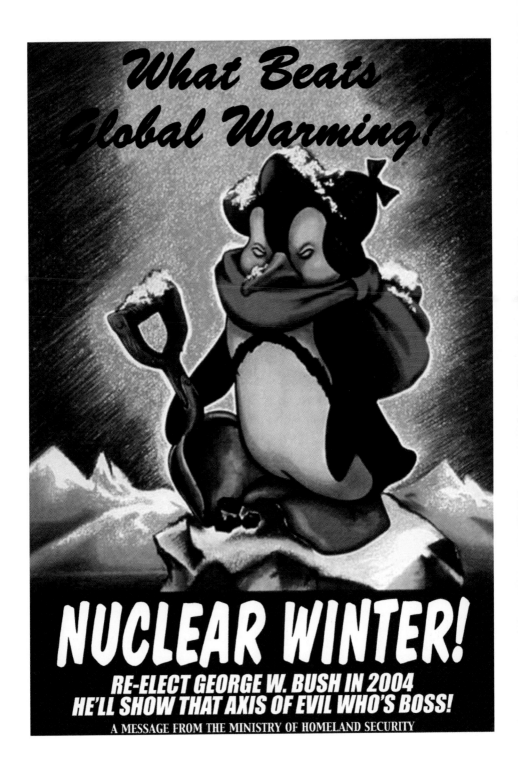

On October 10, 2001, the five major television news organizations—ABC News, CBS News, NBC News, CNN, and Fox News Channel—willingly submitted, without so much as a show of resistance, to a government request that they censor videotaped statements from Osama bin Laden and his followers. The organizations were persuaded to abandon freedom of the press like a sinking ship based solely on National Security Advisor Condoleezza Rice's speculation that such videos might contain coded messages to other terrorists.

Not only did the government fail to offer any support for this speculation, it ignored the fact that uncensored videotapes of bin Laden are broadcast on television stations and Web sites all over the world. What more will American media moguls censor for our benefit? Stay tuned...and perhaps you'll find out. Then again, perhaps you won't.

It is as true today as it ever was that the nation cannot exist half slave and half free." Abraham Lincoln's memorable words were delivered in 1860, just before the start of the Civil War. While the institution of slavery has been abolished, Lincoln's words continue to resonate. Citing the September 11 attacks and the need for tighter border security, the Justice Department has systematically subjected the nationals of Arab and Muslim countries to unjustified interrogation, arrest, and detention. In November 2002, the INS initiated the National Security Entry Exit Registration System (NSEERS), which requires all male noncitizens who are non-residents and are over the age of 16 from designated countries to report to the INS to be questioned, fingerprinted, and photographed. Of the first 20 countries to be designated, all but one—North Korea—were Arab or Muslim. This is only the beginning; by 2005 the INS is required to track each of the approximately 35 million noncitizens who enter and leave the country each year.

On December 16, 2002, the INS office in Los Angeles arrested around 400 men—most of whom were Iranian and Iraqi exiles with minor visa violations—as they went there voluntarily in order to register under NSEERS. These mass arrests sent shock waves through immigrant communities. The NSEERS program has been criticized by Senators Kennedy and Feingold and Rep. Conyers, who have urged the attorney general to reassure the American people that the "special registration program is not a detention program failing just short of widespread internment of Arabs and Muslims."[63]

"THIS WORLD CANNOT EXIST HALF SLAVE AND HALF FREE"
-ABRAHAM LINCOLN

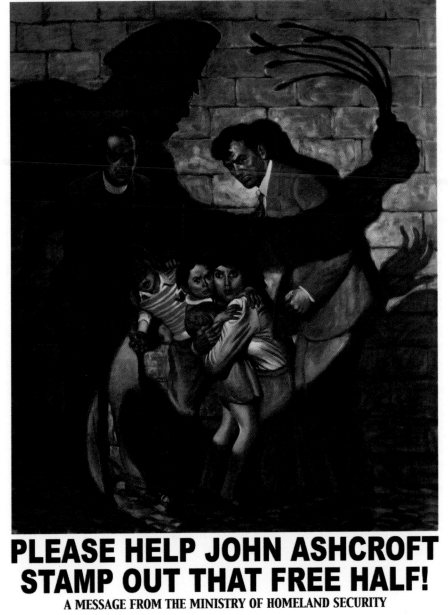

PLEASE HELP JOHN ASHCROFT STAMP OUT THAT FREE HALF!
A MESSAGE FROM THE MINISTRY OF HOMELAND SECURITY

"This war is more akin to World War II than it is to Vietnam. This is a war in which we fight for the liberties and freedom of our country." (Press Conference, March 13, 2002.) With this statement, President Bush all but acknowledged our error in fighting the Vietnam War, a war in which hundreds of thousands of Vietnamese soldiers and civilians and nearly 60,000 American soldiers and civilians were killed. How long will it take before another president recognizes the error of our current adventures? And what will the expense be to the soldiers who serve in these wars and the civilians who are its victims?

Many of the human costs of war are invisible until long after the conflict has been resolved and public attention has turned elsewhere. During the Vietnam War, the U.S. Air Force sprayed at least 11 million liters of Agent Orange over the jungles of Vietnam. Vietnam vets who were exposed to this toxic herbicide had to fight a protracted legal battle to force the Department of Veteran Affairs to pay disability benefits for resultant cancers, skin disease, and other illnesses. Agent Orange has also been blamed for birth defects in the offspring of exposed parents.

The American Gulf War Veterans Association estimates that more than 300,000 of the 700,000 troops who served in the 1991 Gulf War suffer from severe medical symptoms linked to their service. The Department of Defense has yet to offer a satisfactory explanation for the excruciating muscle and joint pain, headaches, chronic fatigue, memory loss, and blackouts that fall under the label of "Gulf War Syndrome." Similarly unanswered are questions about how we will reduce these risks to soldiers in the current war.

The original 1942 poster bore the caption "Defend American Freedom: It's Everybody's Job," and was issued by the National Association of Manufacturers. It pictured Uncle Sam heading off to work taking a job next to Rosie the Riveter in an assembly line.

Upon entering public service, many private-sector executives trumpet the pragmatic skills they have developed in business. These skills, we would like to think, will lead to more efficient government. But today's government officials are more likely to turn in their government hats in order to profiteer as bosses in the war industry. Vice President Dick Cheney's tenure at Halliburton between government jobs is a prime example of this revolving door. While Halliburton's many businesses seem diversified at first glance, a good number of them involve providing expensive support services to the military. Success in this field comes not from competing in the marketplace to satisfy the needs of customers, but rather from insider connections to an elite group of governmental decision makers and legislators, both in the U.S. and abroad.

With the promise of a lucrative private-sector job ahead of him, it's not surprising that Uncle Sam wants to leave the role of international spokesman for the U.S. It has been a thankless job lately, given the growth in anti-American sentiment since the U.S. declared its "war on terrorism." Voters in Germany, South Korea, Brazil, Pakistan, and Turkey have voiced their opposition to America's plans for war on Iraq, and millions of demonstrators in the U.S. have taken to the streets to protest government curtailments of their civil liberties in the wake of September 11, 2001. It's time that Uncle Sam stopped and listened to what so many people are saying.

The original text to this poster read: "Have you REALLY tried to save gas by getting into a car club?" During WWII people recognized that the demands of war necessitated saving fuel. Today, the demands of the oil tycoons necessitate waging war.

In the 1980s, SUVs represented only 2 percent of new vehicles sales.[64] Luckily for the American car industry, the 1991 war against Iraq introduced the civilian population back home to the ass-kicking capabilities of the off-road vehicle. Today, as we gear up for another off-road adventure to secure our oil supply, SUV sales have reached a record level, accounting for 25 percent of new vehicle sales.[65] Ironically, less than 5 percent of SUVs are ever driven off-road.[66] Instead, according to a test-drive by a *Harper's* reporter, behemoths like the Ford Excursion lurch through city streets at 3.7 miles per gallon.[67]

Unfortunately, this mileage per gallon report is hard to verify, as Ford presents no information about fuel efficiency on its Excursion homepage. Indeed, due to the dearth of federal regulation of these SUVs, Ford can list this information as "not available."[68] Even though SUVs pollute at rates double or triple those of small cars, SUVs are subject to far less federal regulation. Most SUVs are required to meet the fuel economy and emission standards set for light trucks, a forgiving category designed to protect the historically small segment of this country that actually needs vehicles with towing and off-roading capabilities.[69] The largest SUVs, such as the Excursion and the Hummer, are so honking huge that they weigh out of the light-truck category altogether and are not regulated *at all*.[70]

Not only does our extreme oil dependence fuel the warmongers, but it also wreaks havoc with our environment. According to the Union of Concerned Scientists, an increase in SUV and light-truck fuel efficiency that is technologically feasible by 2015 could save as much oil as is economically extractable from the Arctic National Wildlife Refuge over 50 years.[71]

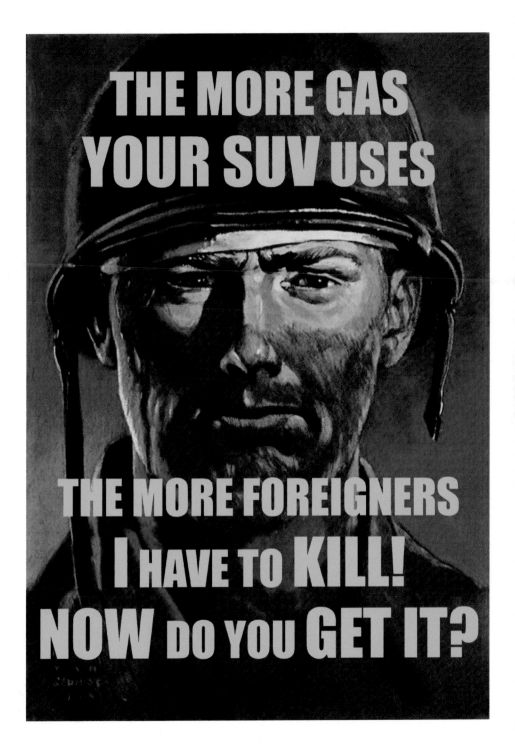

Who will fight it? The burden of fighting and dying in a war against Iraq rests disproportionately on poor people and on African-Americans.

Seventy-six percent of the enlisted men sent to Vietnam were from lower-middle-class or working-class backgrounds, and 25 percent had family incomes below the poverty level.[72] In 1999, the median total gross income for the enlisted population was more than $10,000 a year lower than the median income of the general civilian population.[73]

And while the U.S. military boasts that it has been one of the most integrated institutions in the country since the Vietnam War, civil rights leaders and antiwar activists have long pointed out the negative implications of this seemingly laudable fact. African-Americans made up 14.1 percent of the total of enlisted men who died in Vietnam, while at the time they made up only 11 percent of the young male population nationwide.[74] Statistics from two of the early years of U.S. military involvement in Vietnam, 1965 and 1966, reveal that while African-Americans comprised only 11 percent of the armed forces, their casualties constituted 20 percent of the total.[75] Protests over the use of African-Americans as cannon fodder forced President Johnson to scale back black participation in frontline combat units.

Today African-Americans make up around 30 percent of the entire enlisted force, while they only represent 12 percent of the civilian population between the ages of 18 and 44.[76] The deck appears to be lethally stacked against young African-American soldiers.

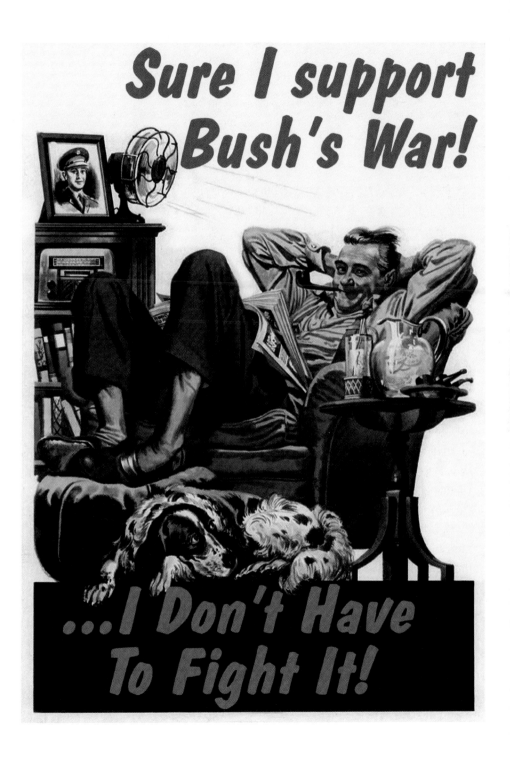

"For what can war, but endless war still breed?"
—MILTON

From a legal perspective, one of the most disturbing things about the "war against terrorism" is how open-ended it is. Like the war on drugs or the war against organized crime, the war against terrorism can never really be "won" and is therefore potentially endless.

The implications of a war without end are Kafkaesque. For example, José Padilla, a U.S. citizen, was arrested at O'Hare Airport in Chicago on his way back from Pakistan, based on government allegations that he was here to plan a terrorist attack with a radiological weapon. Under a recent court ruling, once the government produces "some evidence" of his "enemy combatant" status, he may be held in detention until the cessation of hostilities, whenever that may be.

Similarly, decisions involving "enemy combatant" Yaser Hamdi, an American citizen seized in Afghanistan, and detainees held in the U.S. military base in Guantanamo, Cuba, have confirmed two fears: (1) courts will give the executive almost unlimited latitude in designating persons as "enemy combatants" and hold them without charge or access to a lawyer or the outside world until the "end of hostilities," and (2) the president alone can declare that the hostilities are over. Given the president's statements regarding the uncertain course of the war on terror, what is to stop the president from holding these detainees for the rest of their lives?

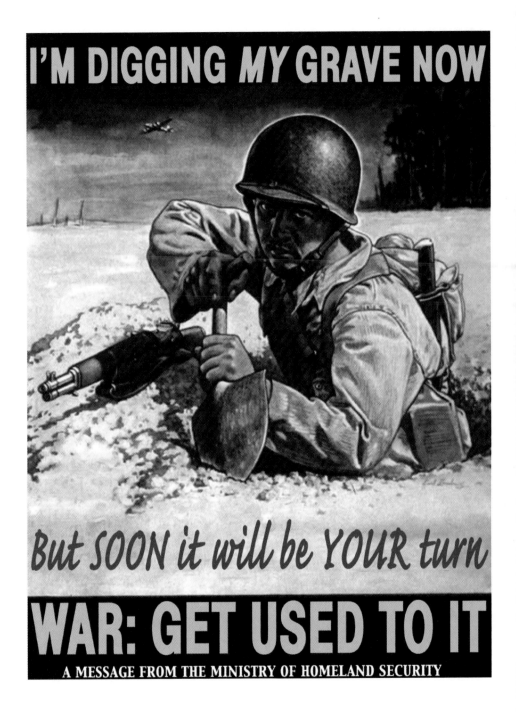

In its relatively short existence, the United States has invaded or intervened in the affairs of an alarmingly large number of countries. The recent invasion of Iraq entitled "Operation Iraqi Freedom," provides a grim reminder of how, time and again, the U.S. uses unfettered might to achieve its aims in the global sphere. The following is an abbreviated list of other U.S. invasions conducted in the last 20 years.

Latin America and the Caribbean: In the 1980s, the U.S. intervened in the Central American liberation struggles by backing the contras against the government of Nicaragua and giving military support to the repressive Salvadoran and Guatemalan regimes. In 1983, the U.S. invaded Grenada ostensibly to rescue American medical students stranded by political turmoil, but in fact to overthrow the government. In 1989, U.S. troops invaded Panama and arrested its leader, General Manuel Noriega, and brought him to the U.S. to face trial on narcotic smuggling charges. In 1991, the U.S. was involved with the coup that overthrew the popular presidency of Jean-Bertrand Aristide of Haiti. Although U.S. troops helped to restore President Aristide three years later, the U.S. undermined his leadership after doing so.

Middle East: During the 1991 Gulf War, U.S. and allied troops went to war with Iraq, ostensibly because of Iraq's invasion of Kuwait, and reinstated the Kuwaiti royal family to power. After that war, the U.S. has intermittently bombed Iraq for violations of a U.S.-imposed no-fly zone. In 2001, the U.S. invaded and bombed Afghanistan in an effort to replace the Taliban regime and eliminate the Al-Qaeda terrorist network.

Europe: In 1999, U.S. and NATO forces attacked Serbia, a part of the former Yugoslavia, to stop attacks on Kosovar Albanians by Serbians. Just prior to the attack, negotiations had led to Serbia's agreement to an international security presence with substantial NATO participation. This presence could have made war unnecessary and renders suspect U.S. claims of a humanitarian purpose.

Africa: From 1992 to 1994, under the humanitarian banner of the UN, U.S. forces occupied Somalia. Over 100 Somalis were killed on the eve of the occupation by U.S. forces. It has been argued that this invasion was not for the purpose of relieving a humanitarian catastrophe, but to provide the U.S. with strategic access to the Horn of Africa. Then, in 1998, the U.S. bombed a pharmaceutical factory in Sudan on the apparently false assumption that it was a terrorist nerve gas production facility, causing civilian deaths.[77]

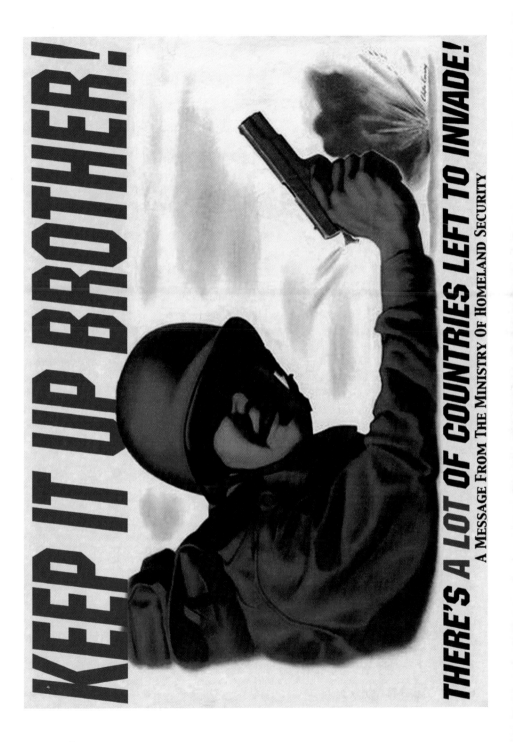

Notes

1 *See* www.bbc.co.uk/science/hottopics/climatechange/kyototreaty.shtml.
2 "Text of a Letter from George W. Bush to Senators Hagel, Helms, Craig, and Roberts," 14 March 2001. *See* www.whitehouse.gov/news/releases/2001/03/20010314.html.
3 Stephanie Mencimer, "Bumper Mentality," *Washington Monthly*, 20 December 2002, available at www.alternet.org/story.html?StoryID=14839.
4 Ibid.
5 AR 350-30.
6 Available at www.whitehouse.gov/news/releases/2002/06/200206013.html.
7 *See*, e.g., Nobel laureate Joseph Stiglitz, "The Myth of the War Economy: Markets Loathe Uncertainty and Volatility. Conflict Brings Both," *Guardian*, Wednesday, 22 January 2003.
8 P.L. 107-110; 20 U.S.C.S. § 6301 et seq. (2002).
9 See 20 U.S.C. § 7908(a)(1).
10 See 20 U.S.C. § 7908(a)(2).
11 Philip Shabecoff, "Dow Stoops to Calm Congress and Public Opinion," *New York Times*, 2 January 1985, sec. B, p. 8
12 *See* www.fair.org/media-beat/021205.html.
13 *See* www.cursor.org/stories/civilian_deaths.htm.
14 *See* www.cbsnews.com/stories/2003/01/24/eveningnews/main537928.shtml.
15 Remarks by the President in Photo Opportunity with Business Leaders, Freedom Hall, 3 October 2001, available at www.whitehouse.gov/news/releases/2001/10/20011003-4.html.
16 "In Bush Budget: Record Deficits," *Orlando Sentinel*, 2 February 2003, p. A3.
17 "Et cetera: Family Ties," *Seattle Times*, 28 January 2002, p. A7.
18 George Lardner Jr. and Louis Ramano, "At Height of Vietnam, Bush Picks Guard," *Washington Post*, 28 July 1999, p. A1.
19 Walter V. Robinson, "Questions Remain on Bush's Service as Guard Pilot," *Boston Globe*, 31 October 2001, p. A14.
20 Jim Lobe, "Chickenhawks Lead Puch for War with Iraq," Interpress Service, 6 September 2002.
21 J. K. Dineen, "Ashcroft on the Grill: Draft-Dodging Alleged as Hearing Opens," *New York Daily News*, 16 January 2001, p. 1.
22 Jim Lobe, "Chickenhawks Lead Push for War with Iraq," Interpress Service, 6 September 2002.
23 Minutes of the Meeting of the Board of Trustees of the City University of New York, 22 October 2001, available at www1.cuny.edu/abtcuny/trustees/thismnth/Min101.htm.
24 Dana Priest and Barton Gellman, "'Stress and Duress' Tactics Used on Terrorism Suspects Held in Secret Overseas Facilities," *Washington Post*, 26 December 2002.
25 *See* www.calltoconscience.net/.

26 *See* www.citiesforpeace.org.

27 Contact nyclaw01@excite.com or LaborAgainstWar@yahoogroups.com for more information about unions' antiwar resolutions.

28 UN Charter, Article 51.

29 George W. Bush, State of the Union Address, 28 January 2003, available at www.whitehouse.gov/news/releases/2003/01/20030128-19.html.

30 UN Charter, Chapter VII, Articles 42 and 43.

31 Phyllis Bennis, "Line-by-Line Analysis of UN Resolution 1441 on Arms Inspections in Iraq," 8 November 2002, www.ips-dc.org/comment/Bennis/res1441.htm.

32 *See* www.opensecrets.org/industries/Indus.asp?Ind=D.

33 *See* www.armscontrolcenter.org/budget/glance03/html.

34 *See* www.askresearch.com.

35 Jonathan D. Salant, "Bush Backer Reaps Profits in California Crisis," 26 January 2001, available at abcnews.go.com/sections/business/DailyNews/enron010125.html.

36 *See* www.guardian.co.uk/flash/0,5860,798061,00.html.

37 Tabitha Morgan, "Iraq Oil Contracts 'To Be Reviewed'," 18 October 2002, news.bbc.co.uk/2/hi/middle_east/2341441.stm.

38 Harvey A. Silverglate, "First Casualty of War," *National Law Journal*, 3 December 2002, p. A21; Richard Huff, "White House Sees Red Over Maher's Remarks," *New York Daily News*, 27 September 2001, p. 112.

39 Attorney General John Ashcroft, "Anti-Terrorism Policy Review," Testimony before the Senate Committee on the Judiciary, 6 December 2001, available at www.history.pomona.edu/vis/02hloor/ashcroft.html.

40 *See* UN Food and Agriculture Organization at www.FAO.org; the International Red Cross at www.ICRC.org; Oxfam International at www.OXFAM.org, or Doctors Without Borders at www.doctorswithoutborders.org/.

41 BBC News Online, "UN Official Blasts Iraq Sanctions," 30 September 1998.

42 Pamela Hess, "US: 'Non-lethal' weapons being developed," United Press International, 31 October 2002.

43 Emily Yoffe, "What Are Rubber Bullets," MSN.com, 4 October 2000, available at http://slate.msn.com/id/1006194.

44 Ian Ith and Janet Burkitt, "Rally Protests Police Actions," *Seattle Times*, 3 December, p. A22.

45 Neva Chonin and John Wildermuth, "Mostly Peaceful Protests Second Day, but Finger Pointing over Monday Melee," *San Francisco Chronicle*, 15 August 2000, p. A15.

46 "Washington Gears Up for New Round of IMF, World Bank Protests," Agence France Presse, 16 April 2000.

47 "Police Rebuff Bush Protesters," available at www.cnn.com/2002/ALLPOLITICS/08/23/elec02.bush.protests/index.html.

48 Ibid.

49 *See* www.epic.org/privacy/terrorism/patriot_foia_complaint.pdf; www.epic.org/privacy/terrorism/usapatriot/foia/.

50 Steve Dunleavy, "Econ Summit Brings Own Terror Threat," *New York Post*, 18 January 2002.

51 *"Confab Welcome, Crazies Not,"* *New York Daily News*, 13 January 2002.

52 David Johnson, "F.B.I. Warns Local Agencies to Be Aware," *New York Times,* 9 September 2002.

53 Tamar Lewin, "The Domestic Roundup: As Authorities Keep Up Immigration Arrests, Detainees Ask Why They Are Targets," *New York Times*, 3 February 2002, sec. 1, p. 14.

54 *See* Clinton and Reno Memoranda on Administration of Freedom of Information Act, press release, Office of the White House Press Secretary, 4 October 1993.

55 *See* "Memorandum for Heads of All Federal Departments and Agencies" from John Ashcroft, attorney general, 12 October 2001, available at www.usdoj.gov/04foia//011012.htm.

56 Howard Zinn, "The Great Deception: Elusive Enemy, Endless War," 27 February 2002, www.tompaine.com/feature.cfm/ID/5175/view/print.

57 William Safire, "You Are a Suspect," *New York Times*, 14 November 2002.

58 "Ways to Prevent Military News Blackouts Sought," United Press International, 6 February 1984.

59 Stanley W. Cloud, "How Reporters Missed the War," *Time*, 8 January 1990.

60 Matthew Rothschild, "The New McCarthyism," *The Progressive*, January 2002, p. 21.

61 Ibid.

62 Andres Buncombe, "Veteran Anchor Attacks Media for Being Timid," *Independent Digital*, 17 May 2002; Matthew Engel, "US Media Cowed by Patriotic Fever, Says CBS Star," *Guardian*, 17 May 2002.

63 Letter to the attorney general, 23 December 2002, available at www.aclu-mass.org/general/SpecialRegistration.html.

64 Paul Roberts, "Bad Sports," *Harper's,* April 2001.

65 "SUV Environmental Concerns," The SUV Info Link, available at www.suv.org/environ.html.

66 Keith Naughton, "The Unstoppable SUV," *Newsweek,* 2 July 2001.

67 Paul Roberts, "Bad Sports," *Harper's,* April 2001.

68 *See* www.fordvehicles.com/suvs/excursion.

69 "SUV Environmental Concerns," The SUV Info Link, available at www.suv.org/environ.html.

70 Ibid.

71 *See* www.ucsusa.org/global_environment/biodiversity.

72 Vietnam War Statistics available at www.no-quarter.org/html/jake.html.

73 "Background Briefing on the All Volunteer Force," United States Department of Defense, 13 January 2003, available at www.defenselink.mil/news/Jan2003/t01132003_t113bkgd.html.

74 "Vietnam War Casualties by Race, Ethnicity and National Origin," available at http://members.aol.com/WarLibrary/vwc10.htm.

75 Ibid.

76 "Background Briefing on the All Volunteer Force," United States Department of Defense, 13 January 2003, available at www.defenselink.mil/news/Jan2003/t01132003_t113bkgd.html; and Maura Jane Farrelly, "Race, Class, and the Draft," *VOA News Report*, available at www.globalsecurity.org/military/library/news/2003/01/mil-030108-2317e09d.htm.

77 "Let the Bloody Truth Be Told: A chronology of U.S. Imperialism," available at www.neravt.com/left/invade.htm.; "A History of U.S. Intervention in Latin America and the Caribbean," available at http://kuhttp.cc.ukans.edu/cwis/organizations/las/interven.html.

Original Poster Sources

<p style="text-align:center">PAGE 25
Artist unknown, USA, 1952</p>

<p style="text-align:center">PAGE 27
Pat Keely, British Poster for the
Dutch Government, 1944
TRANSLATION:
"Work and Fight to Free the Indies"</p>

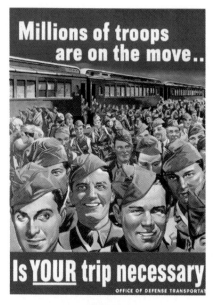

PAGE 29
Jerome Rozen, USA, 1943

PAGE 31
Artist unknown, USA, 1943

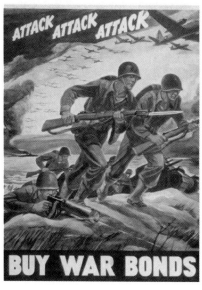

PAGE 33
Ferdinand E. Warren, USA, 1942

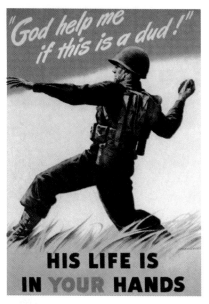

PAGE 35
John Vickery, USA, 1942

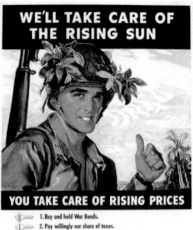

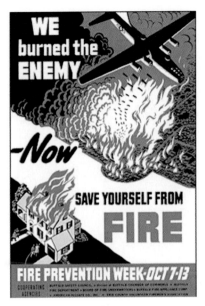

PAGE 37
Artist unknown, USA, 1945

PAGE 39
Artist unknown, USA, 1944

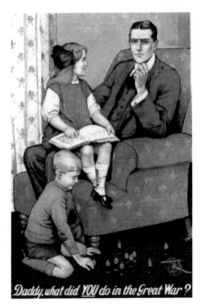

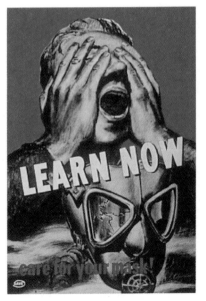

PAGE 41
Savile Lumley, Great Britain, 1915

PAGE 43
Artist unknown, USA, 1942

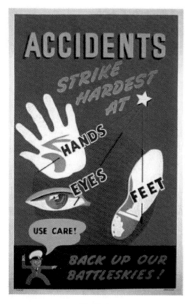

PAGE 45
Artist unknown, USA, 1942

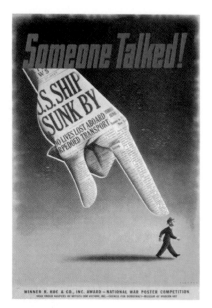

PAGE 47
Artist unknown, Great Britain, 1942

PAGE 49
Artist unknown, France, 1942
TRANSLATION:
"To be silent is to be useful"

PAGE 51
Artist unknown, USA, 1942

PAGE 53
Artist unknown, USA, 1943

PAGE 55
Artist unknown, USA, 1942

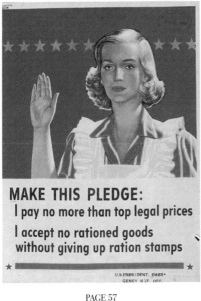

PAGE 57
Artist unknown, USA, 1942

PAGE 59
McClelland Barclay, USA, 1942

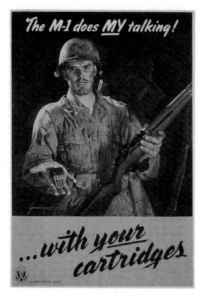

PAGE 61
Jes Schlaikjer, USA, 1943

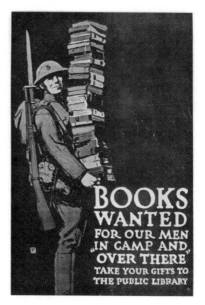

PAGE 63
Charles Buckles Falls, USA, 1918

PAGE 65
C. R. MacCauly, USA, 1917

PAGE 67
Artist unknown, Canada, 1942

PAGE 69
Artist unknown, USA, 1942

PAGE 71
Artist unknown, USA, 1942

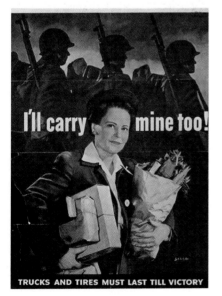

PAGE 73
Sarra, USA, 1942

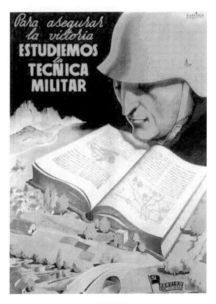

PAGE 75
Parilla, Spain (Republican), 1937
TRANSLATION:
"In order to assure victory, study
military tactics"

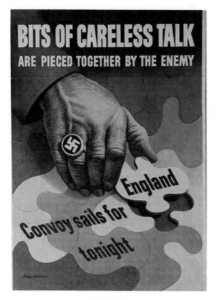

PAGE 77
Steven Dohanos, USA, 1943

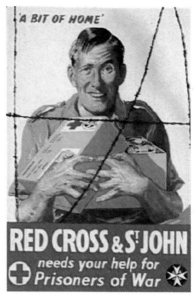

PAGE 79
Artist unknown, USA, date unknown

PAGE 81
Georges Schreiber, USA, 1943

PAGE 83
Artist unknown, USA, 1942

PAGE 85
Artist unknown, USA, 1951

PAGE 87
Artist unknown, USA, 1943

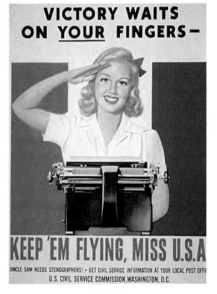

PAGE 89
Artist unknown, USA, 1943

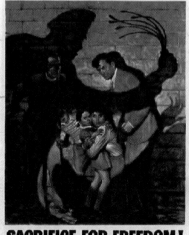

PAGE 91
John Falter, USA, 1942

PAGE 93
Artist unknown, Soviet Union, 1944
TRANSLATION:
"Victory! Victory! Victory!"

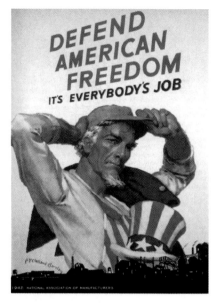

PAGE 95
McClelland Barclay, USA, 1942

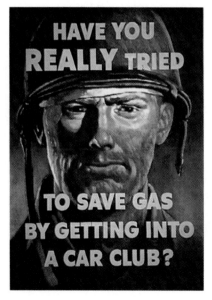

PAGE 97
Artist unknown, USA, 1943

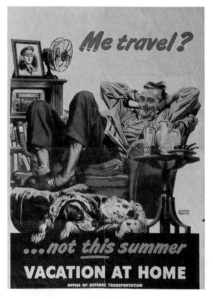

PAGE 99
Artist unknown, USA, 1943

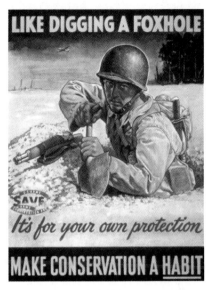

PAGE 101
Artist unknown, USA, 1944

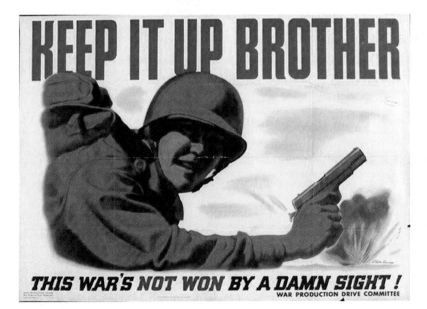

PAGE 103
Artist unknown, USA, 1943

About the Authors

After four years spent invading other countries as an Airborne Ranger in the U.S. Army, **MICAH WRIGHT** moved on to the next logical step in his career: writing children's animation. Upon earning a degree in political science and creative writing from the University of Arizona, Micah relocated to Los Angeles and began writing at Nickelodeon Animation.

Micah's writing for Nicktoons' *The Angry Beavers* was nominated for an Emmy and an Annie award. Micah also created the first true American anime show, Constant Payne, his homage to the pulp novels of yesteryear. He is also co-creator of the acclaimed "Chet Thunderhead: Private Eye" animated series.

A lifelong comic-book reader, Micah currently writes *Storm Watch: Team Achilles,* a blood-and-guts vision of human special forces soldiers who do battle with out-of-control superheroes and the sinister Military-Corporate Complex that creates these supersoldiers gone mad.

KURT VONNEGUT is among the few grandmasters of 20th century American letters, one without whom the very term American literature would mean much less than it does now. He was born in Indianapolis, Indiana on November 11, 1922. Vonnegut lives in New York City.

HOWARD ZINN grew up in the immigrant slums of Brooklyn where he worked in shipyards in his late teens. He saw combat duty as an air force bombardier in World War II, and afterward received his doctorate in history from Columbia University and was a postdoctoral Fellow in East Asian Studies at Harvard University. His first book, *La Guardia in Congress,* was an Albert Beveridge Prize winner. He is the author of numerous books, including his epic masterpiece, *A People's History of the*